IMAGES
of America

COHOES REVISITED

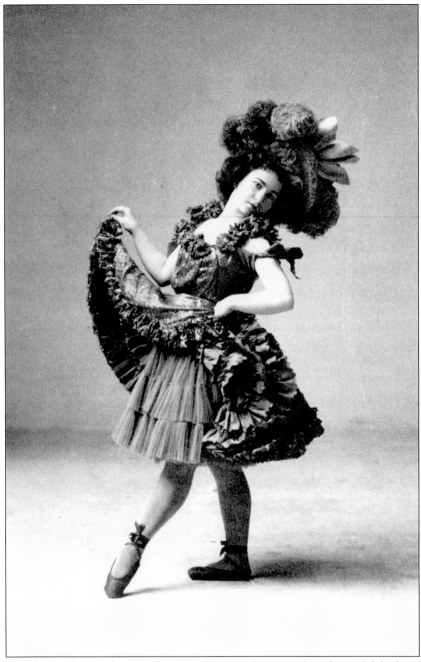

Mary Adelaide "Addie" Dickey was born on Remsen Street to Josephine Adelaide Abel and William James Dickey in 1882. She danced on the stage of the National Bank Music Hall in Cohoes in 1893 and went on to become a legendary vaudeville dancer. She was first billed as La Petite Adelaide and later, simply Adelaide. In 1913 she wed her dancing partner J. J. Hughes and future billing was as "Adelaide & Hughes." This cabinet card was taken for an 1897 production of *The Belle of New York*. The show featured the Anti-Cigarette Society of Cohoes and introduced the song "Far From Cohoes." The writers of the show created the song upon hearing Adelaide discuss her hometown. It is to Addie that this book is dedicated.

IMAGES
of America

COHOES REVISITED

Spindle City Historic Society

ARCADIA
PUBLISHING

Copyright © 2005 by Spindle City Historic Society
ISBN 978-0-7385-3943-0

Published by Arcadia Publishing
Charleston SC, Chicago IL, Portsmouth NH, San Francisco CA

Printed in the United States of America

Library of Congress Catalog Card Number: 2005933109

For all general information contact Arcadia Publishing at:
Telephone 843-853-2070
Fax 843-853-0044
E-mail sales@arcadiapublishing.com
For customer service and orders:
Toll-Free 1-888-313-2665

Visit us on the Internet at www.arcadiapublishing.com

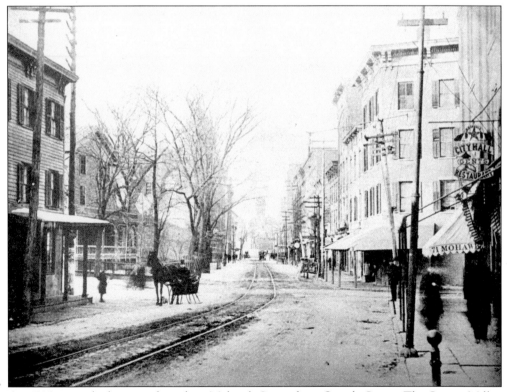

An 1890s view, looking northward on Mohawk Street from Oneida Street. The Strong Mill is the tall building in the distance at the head of the street. Larkin Hall is on the right, with the City Hall Restaurant on the first floor. Note the horse-drawn sleigh, the trolley tracks down the street, and the posts on the right for tying up horses. The building in the left foreground later became Cramer's clothing store.

CONTENTS

ACKNOWLEDGMENTS

The Spindle City Historic Society's Arcadia Committee has had the assistance and cooperation of many individuals in the preparation of this book. They loaned us their cherished artifacts and their memories in the form of photographs. We are indebted to them for their generosity. Without their help, this book would have been impossible. We thank Dorothy Amyot, Barbara LaPorte Bailey, Susan Beattie, Corinne Bechard, Raymond Bernard, Marjorie Borden, Monica Bourgeois, Paul Bourgeois, Thomas E. Cannon, Barbara Carr, June Cherniak, Cohoes Library, Caroline Comi, Larry Crandall, Marilyn Craner, John Craner, Donna DeMarse, Percy Duda, Paul Dunleavy, Margaret Eighmey, Dennis Fafard, Austin R. Gagnon, Frank Galarneau, Frank Gebosky, Veronica Krutka Geesler, Kathleen Gill, Marian Guerin, Fran Hanlon, Catherine Helck, Pam Hungate, Larry Kavanaugh, Frank Kennedy, Mary Neeson Kennedy, Lois Kosko, Frances Krawczyk, Steve Lackmann, Alfred LaMarche, Lea Langlais, Helen Maxwell, Barbara McDonald, Joan McGrail, Romeo Mitri, Rita Moss, Anne Marie Nadeau, Bernard Ouimet, Fran Plouff, Hank Plouff, Olive Potts, Yvonne Blair Richardson, Donna Riley, Dennis Rivage, Riverspark, John Rowan, Ann Marie Roy, Sheila Sbrega, Gregory Schwartz, Joan Seguin, Tor Shekerjian, Luke Sheremeta, Bert Tremblay, Jeanne Trudeau, Mike Wheeler, and Diane White for their contributions.

The Spindle City Historic Society hopes this book, through its photographic record, will strengthen the knowledge about and appreciation for the history of Cohoes. If there have been oversights, or if readers can supplement the information in captions accompanying the photographs, we kindly ask you to inform us. Please contact the Spindle City Historic Society at P.O. Box 375, Cohoes, NY 12047, or through our website at http://www.timesunion.com/communities/spindlecity or http://www.spindlecity.org. We will post corrections, as well as supplemental information to the photographs in this volume, on our website. Your help is always appreciated and vital to extending our knowledge of Cohoes history.

—The Spindle City Historic Society

Daniele Cherniak	Anne Marie Nadeau
June Cherniak	Donna Riley
Walter Cherniak	Dennis Rivage
Linda C. Christopher	Tor Shekerjian
Paul D. Dunleavy	

INTRODUCTION

Cohoes traces its recorded history back to the 17th century, when it was a farming community of Dutch settlers. Remnants of Cohoes's past extend back to the Ice Age, when a mastodont met its demise a short distance from the Cohoes Falls. Its bones were discovered when excavating for Harmony Mill No. 3 in 1866. The find created a national sensation, and the mastodont remains a treasured symbol of the city.

Before the arrival of Europeans, Native Americans settled along the riverbanks near the confluence of the Hudson and Mohawk Rivers. The Cohoes Falls played a significant role in the formation of the Haudenosaunee (Iroquois) Confederacy. Benjamin Franklin later met with the Haudenosaunee at the falls and learned of their agreement, which would be an inspiration in drafting the Constitution of the United States. Cohoes was a strategic site during the American Revolution. American forces camped on Van Schaick Island while preparing to engage the British at Saratoga, and the Van Schaick mansion became the headquarters of the colonial forces.

The falls were visited by many others of note; Henry Hudson and his crew were the first Europeans to see them. During the 17th and 18th centuries, the falls were viewed as a natural wonder, inspiring poets and artists, or as an obstacle to surmount on water journeys. By the Industrial Revolution of the 19th century, the falls were a source of power to drive manufacturing.

Cohoes became an industrial center because of the falls, its location near the Hudson and Mohawk Rivers, and the junction of the Champlain and Erie Canals. The first industries were sawmills and gristmills. A pioneering attempt at manufacturing began in 1811 when the Cohoes Manufacturing Company set up a factory to manufacture screws. Cohoes consisted of a population of 150 people up until 1840, but growth soon became so rapid that the population rose to 4,000 in 1848. Cohoes was incorporated as a village in that year, and became a city in 1870. Cohoes was also shaped by the construction and operation of the Erie Canal. The original "Clinton's Ditch," completed in 1825, had 19 locks in Cohoes; its replacement, the enlarged Erie Canal, had 10. The multitude of locks to surmount the Cohoes Falls made for slow travel, but encouraged development of businesses to serve and supply the canalers. The canal was an effective means of transporting raw materials in and finished goods out of Cohoes, and greatly assisted the rapid growth of the community and its industries.

Two companies were responsible for the growth of Cohoes: the Cohoes Company and the Harmony Manufacturing Company. The Cohoes Company, under the guidance of Erie Canal engineer Canvass White, built six power canals to provide waterpower to prospective

manufacturing enterprises. The canals used the same water six different times before its return to the river. This power source enabled the Harmony Manufacturing Company to be formed in 1836. Its first mill was constructed in 1837, located adjacent to the Erie Canal. By 1850, the mill was sold, and the new owners hired Robert Johnston, a protégé of Samuel Slater, as manager. Johnston's tenure marked the beginning of the Harmony Mills' success, and Cohoes would be a one-company town by the 1880s. The company would eventually own a complex of mills which, by 1900, produced 1.6 million yards of cotton cloth a week. With certainty of employment, people flocked to Cohoes. The Irish, who remained after construction of the Erie Canal, were joined by French Canadians in the 1870s and 1880s. They were followed by groups of Italian, Polish, Russian, and Ukrainian immigrants, along with many others who have collectively given the city its distinctive character.

This book traces the history of Cohoes from the height of its industrial power in the late 19th century, through World Wars I and II, the Great Depression, and the societal and technological changes of the 20th century. The story is told through photographs and through the eyes of an observer, Helen Dickey, who recounts experiences of life in Cohoes over the years in letters to her sister Adelaide. While the letters themselves are recreations, Helen and Adelaide Dickey were real people, and the events and details described reflect circumstances and occurrences of the time periods.

William James Dickey, father of Adelaide and Helen, was superintendent of the Egbert and Bailey Woolen Mill in Cohoes and built a stick Victorian house in 1890 which still stands at the crest of Imperial Avenue. Adelaide appeared on the stage of the current Cohoes Music Hall in 1893, billed as La Petite Adelaide. She went onto the vaudeville circuit under such producers as George Lederer, Lee and J. J. Shubert, B. F. Keith, the Hammersteins, and Ned Wayburn.

Her first movie was made in 1898. She had the longest run of any performer at the Casino Theatre and her run at the Palace Theater was only outdone many years later by Judy Garland. Adelaide and her husband J. J. Hughes appeared in countless productions from 1894 until 1927. The dance teams of Fred and Adele Astaire and Vern and Irene Castle are only better remembered because they hit their popularity with the advent of "talkies," and Adelaide had already been dancing for 40 years.

Cohoes has a fascinating and exciting past, and its history is a catalyst for the future. Preserving and celebrating the city's heritage and historic architecture will ensure the vitality of Cohoes.

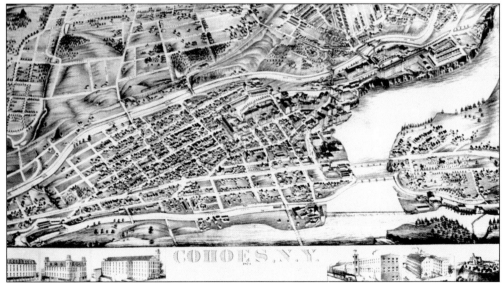

This map published by Galt and Hoy shows Cohoes in 1879 with its power and transportation canals and the Mohawk and Hudson Rivers, all of which shaped the city's history.

One

1890

To my sister Adelaide,

Our assignment for class today is to write to a person we admire and tell them about our hometown. Miss Jones, my teacher at White Street School, said we have only three days to complete the letter, but she gave me an additional day since we just moved into our new house on Imperial Avenue. The train whistles scare me with the trains going right behind the house. Maybe Mother and Father will let us play at New York Central Railyard near High Street.

Addie, there is no one I admire more than you. When I watch you at Mr. Van Arnum's dance class in Troy, my heart just soars with your graceful movements. Oh, how I wish I could dance half as well as you. You will put so many dancers to shame if you become famous, or should I say, when you become famous. And, to think, I'm your little sister and we share our own brand new bedroom! I wonder if you will be selected this year to dance at the National Bank Hall. It is such a wonderful music hall. That long marble staircase up to the lobby is so grand.

There are other famous people in Cohoes that I must tell you about. First, there is the Cohoes Mastodont, but he is really old and big. His bones were found in a pit where they built that big mill by the river. His bones are in the Cabinet of Natural History in Albany and our teacher said we could go down and see them. Second, there is an Indian maiden that went over the falls in a canoe. The only falls bigger in New York State are found in Niagara. This maiden supposedly gave our city its name. Cohoes means "falling canoe." Thirdly, and lastly, there is President Chester A. Arthur. He taught in Cohoes, and was the principal of Cohoes Academy. Mark Twain lectured here too.

Cohoes was important during the Revolutionary War. Many famous generals were here then. George Washington even visited that old house on Van Schaick Island twice. My teacher told us that Cohoes became a city in 1870. Just 50 years ago, 150 people lived in Cohoes. I think there are more people than that in our school right now, let alone the whole city. Because of the mills, we are a city of immigrants. The Irish, French Canadians, Italians, Poles, Russians, Ukrainians, and so many others, all came here to work in the mills, just like the one Father runs. They also built all those beautiful churches we love to look at when we take out the horse and carriage.

Do not tell Mother, but Father purchased a beautiful bracelet for her at Timpane's Jewelers. I have not said this out loud for fear of her hearing me and ruining the surprise. He bought it to match the dress Mother is having made by our old neighbor, Julia Michaud.

There are so many wonderful things to say about Cohoes. Today, when I was walking home, I stopped and watched a barge going up the Erie Canal before I went up High Street. They are so much quieter than the trains. But Father says the mules cannot move as much merchandise as the locomotives. The only thing Father does not like about the trains is that they scare the horses. He also mentioned that he has to get the mare to Mr. Amyot for shoeing. I still have to be walked home because of all the construction down in the city. Cohoes is such a wonderful city, with so many great old buildings, I wonder what those people building the new ones have in store for us next.

Do you think that we will get any more snow? Remember two years ago when we still lived on Remsen Street and we had that blizzard? The snow drifts were up to second story windowsills and Father had to dig a tunnel from the front door to the cleared area in the street so he could walk to work.

I hope both you and Miss Jones like my letter. I also hope my penmanship has improved. I saw a picture today in the principal's office at school. It showed a graduating class from 1883. My, the girls were beautiful. I hope I can do well enough to graduate from Egberts High School. So many of my friends have left school to go work in the mills. I practice my reading when Father lets me read the articles he selects from the *Cohoes Daily News*.

I think I shall sign my letter as . . .

Your loving sister, Helen

This photograph was taken on North Mohawk Street. Pictured is Julia Michaud, on the top left is Alma Lajeunesse; the others are unknown. Lajeunesse, a spinner, boarded at 6 North Mohawk Street. Michaud, a dressmaker, lived at 171 Remsen Street. The two women in dark clothing wear chokers of pearls; it was a custom to give young girls a few strung pearls, which were added to as the years progressed.

Bruno Amyot (1827–1917), an immigrant from Vercheres, Quebec, who worked as a blacksmith, poses with family members in this late-1800s photograph. Three of his nine children grew up to become dentists. The house was located at the foot of Oneida Street at the Mohawk River and Champlain Canal, not far from where the northernmost terminus of Route 787 is today.

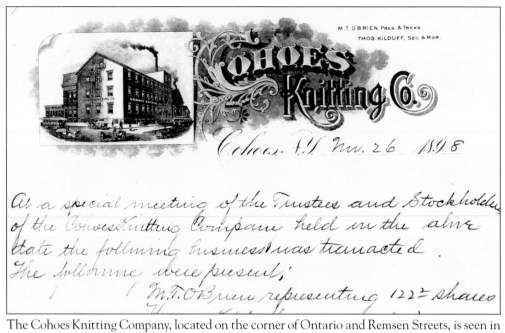

The Cohoes Knitting Company, located on the corner of Ontario and Remsen Streets, is seen in this letterhead that also shows a group of the mill's workers. The mill made woolen underwear.

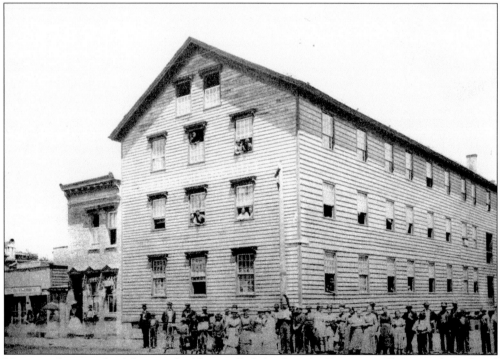

Here is a photograph of the same building, called the Ontario Knitting Mill. It was also referred to as the Old Clapboard Mill. The building was demolished in 1906. The Bank of America (earlier the Mechanics Bank) now stands at the site. The lower building in the back was later a haberdasher. Its proprietor was a Mr. Wallace.

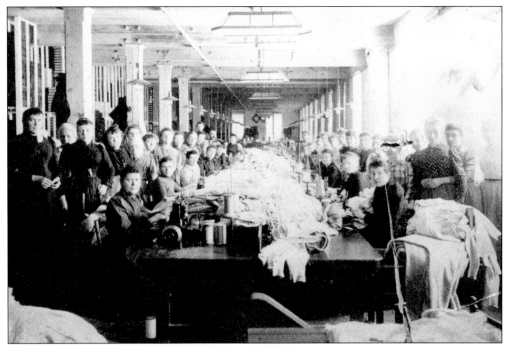

This photograph was taken around 1890 of an unknown company. There were more than 40 hosiery and knit goods manufacturers listed in the Cohoes City Directory in 1890. Workers were often paid by the piece. To save money and avoid fire, most of the lighting was provided by the large windows. Ventilation was facilitated by the high ceiling, as the windows were kept shut to keep lint from flying about.

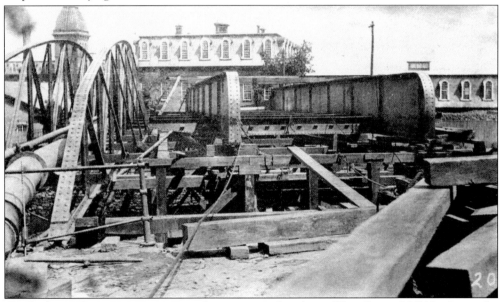

The bridge under construction spans the power canal on lower Vliet Street. Mill No. 3 is in the background to the left, Mill No. 2 is to the right. This bridge and others like it replaced crossings via footbridges and planks, which were hazardous at night and during inclement weather. The new spans provided a better connection from the Harmony Hill neighborhood to downtown.

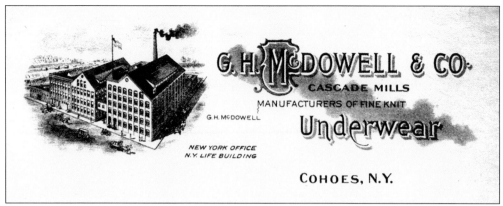

G. H. McDowell became proprietor of the Egberts Woolen Mill, located at 87 Ontario Street. The mill, renamed G. H. McDowell and Company, remained there until 1883 when it moved to 301 Ontario Street. In 1889, it became the Cascade Mills under McDowell's management. The company, manufacturer of fine knit underwear, was relocated to 101 Heartt Avenue, at the corner of River Street, on Van Schaick Island.

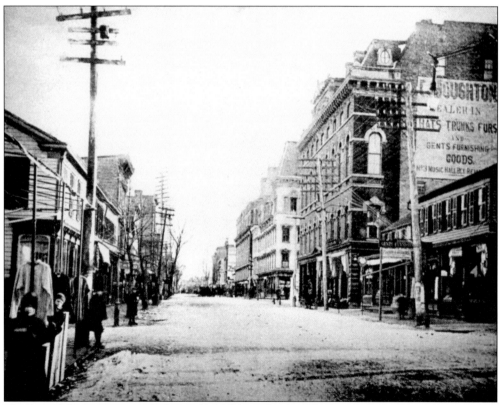

This late-19th-century view, looks southward down Remsen Street. The nearest corner is Factory Street (now Cayuga Street). The National Bank Building (now the Cohoes Visitor's Center and Music Hall) is on the right. The Silliman Block is just to the south, on the same side of the street.

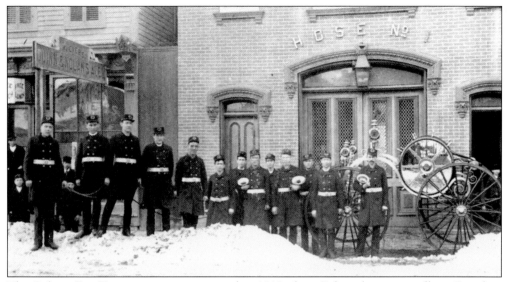

The Cohoes Fire Department was organized in 1848 when Cohoes became a village. Standing in front of 89 Main Street is the Hitchcock Hose Company, begun in 1868. The men in the photograph were volunteers except for the drivers who were paid. This station also housed the Leversee Hose, established in 1897, and the Hose Company No. 1. The Cohoes Armory parking lot now occupies this site.

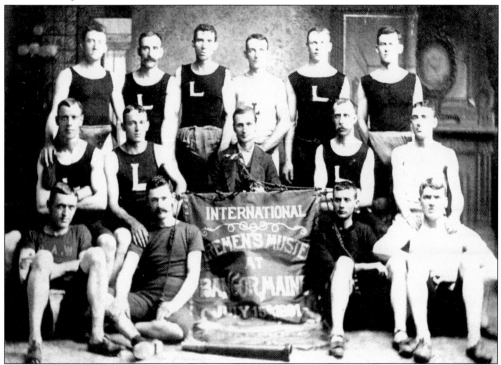

Here is a team picture of Cohoes firefighters at the International Fireman's Muster at Bangor, Maine, on July 15, 1891. The muster was a series of competitions among groups of firemen, usually attended by fire companies from far and wide. The company's hose nozzle was highly prized, and is proudly displayed here in the foreground.

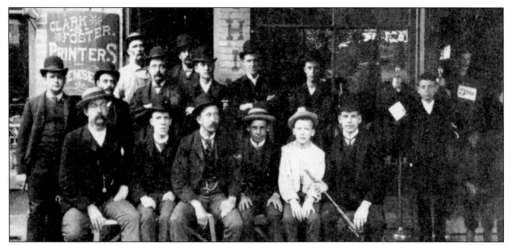

This is a group of workers in front of Clark and Foster printers, 1872, located on Remsen Street. In 1872, printers Richard S. Clark and Eugene H. Foster formed the Clark and Foster Company. It was located in Granite Hall at the corner of Remsen and Ontario Streets. In 1877, the firm published the first issue of the *Cohoes Daily News*. The partnership lasted until 1892 when Foster began his own company.

This *c.* 1883 photograph shows Egberts High School students surrounding their serious, bespectacled teacher. The school, located at the northwest corner of White and Mohawk Streets, was built by Egbert Egberts in 1858 and functioned as an educational institute and high school for Cohoes. Anna Jennette Bentley is at the far right. Anna's father, William Niles Bentley, ran a boarding house for Harmony Mills workers.

Two

1899

12 December 1899

My dearest sister,

Addie, it seems like years since I have seen you. Now that you are performing regularly in New York you never seem to be home. I have so much to tell you. Home, just like the rest of the world, is changing so quickly. Father just got home from shopping down on Remsen Street. You should hear him about the prices! He sat mother down and they went over expenses for hours. It all started with him wanting a new suit since he is superintendent at the Egbert and Bailey Woolen Mill.

He could not believe that a new suit could cost $12. He caused such a stir the clerk showed him one for $3.90. That suit started it all. Mother had to go over all the household expenses, from the porterhouse steak at 15¢ a pound, to frankfurters, which are three pounds for 25¢. They discussed how corned beef or stew beef was 6¢ per pound, and all types of canned vegetables were priced at three cans for 25¢. He had to know that toothbrushes, talcum powder, and bars of soap sold for 4¢ each.

Oh, you should have heard him. He told Mother that he could not understand how the Harmony Company was starting to install electric motors in all of their mills, thus signaling the demise of waterpower, yet a pound of coffee was going up to the ridiculous price of 25¢ a pound. Mother was practically in tears when she had to tell him the new rocking chair cost $2.50 and the lace curtains in the front parlor were 61¢ per pair. He finally calmed down but did not stop his elocutions. Mother had to endure hearing about how Cohoes building lots were advertised in the newspaper for a down payment of $2.50 per week on a total cash payment that ranged between $26 and $48, depending on the lot. Mother said that with all this fuss that she would have to place a Gideon Bible in every room, just like they are starting to do in all the hotels.

Did I tell you that in October, Gov. Theodore Roosevelt came to Cohoes to give the opening remarks for St. Bernard's three-week long Fall Festival? People still talk of how well you danced at the Children's Kermiss for St. Bernard's Academy, and that was almost four years ago. Another story that will be remembered for a long time is how that daredevil Bobby Leach rode over the Cohoes Falls in a barrel!

Our city is changing so much. Congress Street was extended to Lincoln Avenue, thus creating a thoroughfare. A memorial with a cannon was dedicated at McKinley Square, at the head of Oneida Street next to the National Bank Building, and all this 34 years after the Civil War. I

met some girls at the dedication who are going to the new Catholic school on Vliet Street when it opens.

Father had quite the laugh with our neighbor who is a policeman. Evidently, in August of 1891, Cohoes mayor Garside ordered all obscene lithographs displayed in store windows or on billboards taken down by the police. Well, our neighbor followed orders and took them down, but he saved them and forgot about them. They were taken down because too many ankles were revealed! My how times have changed. Father was not even offended by them. (But he did not show Mother or me.)

Did you hear that Congress approved the use of voting machines for federal elections? Yet, women still cannot use them because we cannot even vote. I wonder if Governor Roosevelt will be re-elected in 1902? People say that is why he was in town for the dedication. Father also said he was never going to get his hair cut again; he is tired of all the politics discussed every time he gets his hair cut. He says that the barber should turn in his scissors and become the mayor or even the governor. He says this town is full of members of the "Idle Hour Club." Every hour, they are nothing but idle.

A new Opera House opened several blocks down from the one in which you performed. It was built in the style of many New York City theaters, so you will feel right at home when you perform there. The falls are so dry this season that many people are walking back and forth across them. Maybe you and I can do this when you come back to visit us. I love to parade up and down Remsen Street and show you off each time you come home. Isn't that terrible of me?

<div align="right">Your loving sister, Helen</div>

This photograph, from early in the first decade of the 20th century, is of (from left to right) Annie and Maggie Sheridan and Hattie McCue standing in front of a rooming house in Cohoes; Annie and Maggie boarded at 4 Strong Place. Maggie worked in the mills of Cohoes (as a winder) as a young woman. Her millworker experiences have been recreated by her niece, storyteller Kathleen Gill, as tales of "Millhand Maggie." Maggie's friend Hattie McCue served as a nurse in World War I.

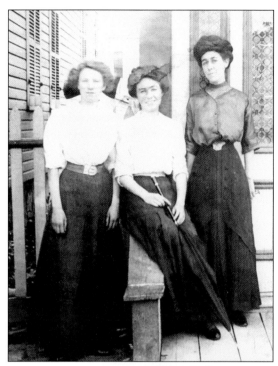

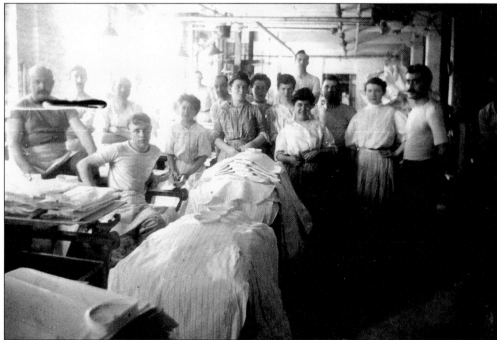

A group of mill workers is shown with stacks of shirts ready to be shipped following pressing and folding; shipping was done in boxes made in a Cohoes box factory. Notice that the shirts have banded collars. Shirt collars (many of which were manufactured in nearby Troy) were purchased separately by the dozen, as only the more easily soiled (and more easily washed) collar was changed daily, not the shirt.

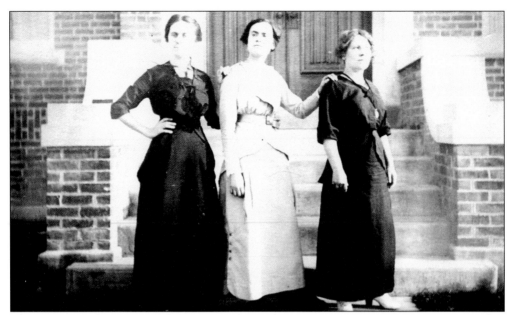

The woman in the center of this group in front of St. Marie's rectory is Lucy Mann, a tireless worker for the church and choir member for many years. The parish was chartered in the early years of the 20th century, and the majority of parishioners in the earliest days of the church were French Canadian families who settled in the "hill" section of the city.

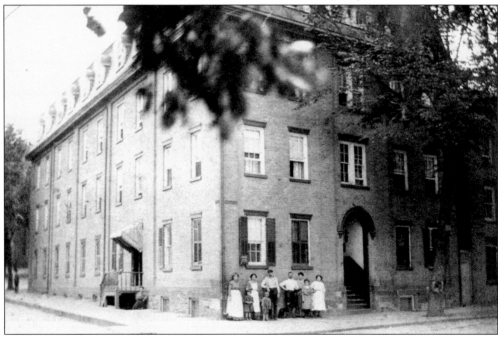

This boardinghouse was largely occupied by single mill workers at the Harmony Mills. Married workers and families occupied the company row houses along North Mohawk Street and up Harmony Hill on Vliet and other nearby streets. The boarding house was advertised in a booklet for worker recruitment as "Steam heated, clean and sanitary," with rates ranging from $2.50 to $4.00 per week. The boarding house later became the Hilltop Hotel.

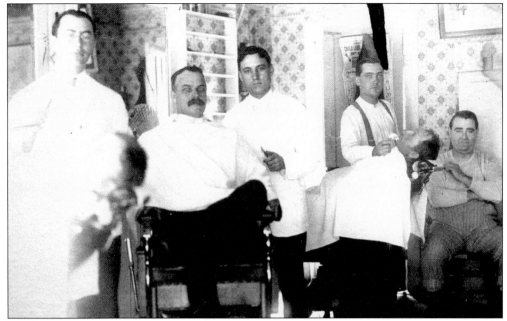

Shown here are Cohoes Democratic party leader Michael T. "Big Mike" Smith, Jack Burns, barber Hector Bechard, Dr. Daunais, and Emile Rivet around 1905. The barbershop was long a place to hear the news of the city and discuss politics. Smith, who got his start in local politics in the 1890s, held tight control of Cohoes's Democratic politics through the 1930s.

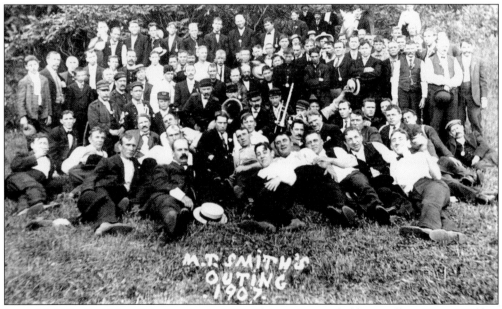

ictured is Mike Smith's political outing in 1907. This outing was held annually at Camp Wolf on the Mohawk River. Mike Smith gathered political power in Cohoes through the early years of the 20th century, becoming a legendary figure in local and state Democratic Party politics. Note the band instruments and two ladies lurking in the background. These gatherings promoted Democratic Party solidarity and loyalty, and a good time was had by all.

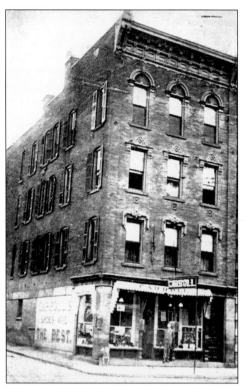

This building housed Carroll's Shoe Store from 1903 to 1906. The sign above the entrance reads: "The Home of Good Shoes." The building was destroyed by fire in December 1967. At that time, Waldman's Army and Navy Store occupied the building. According to the *Troy Record* on December 23, 1967, "Waldman's and Juliette's were among the most popular stores in the city and considered magnets helping draw downtown shoppers."

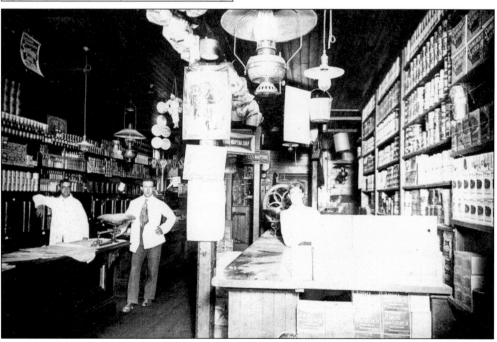

Page's Grocery is pictured here on August 24, 1899. Behind the counter is Arthur Bessette, the butcher. In front of the counter is Henry Hebert. There were two Page's groceries in the city at the time—Alfred Page had a meat market at 98 Mangam Street, and Samuel T. Page had a meat market-grocery at 49 Saratoga Street.

Old Cohoes

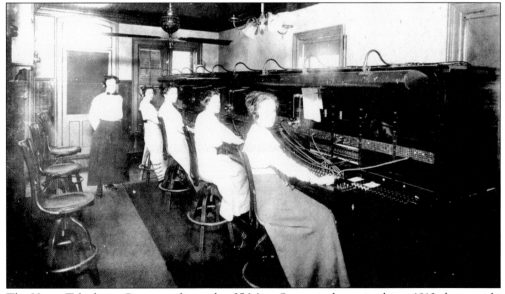

Archambeault's bakery was opened in 1888 by Matthias Archambeault on 16 Willow Street. He appears here in the doorway with his children Clair and Tancrede. On the left side of the shop are his bakers Frank La Forest (far left) and Hector Janette. His delivery carriage advertises his pies and cakes.

The Home Telephone Company, located at 35 Main Street, is shown in this c. 1910 photograph. O. J. Hawkins was the manager and Edith Much was the secretary. Edith Much later married Hawkins. Although Hawkins was the manager, there were times when he had to repair telephone lines and other system problems. Note the combination gas and electric ceiling light with the popular ceiling fan behind it.

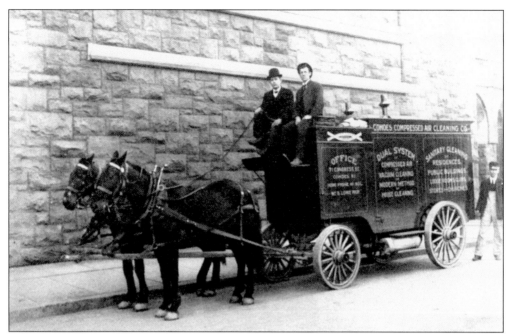

The Cohoes Compressed Air Cleaning Company's wagon is parked in front of St. John's church for this photograph. The business was located at 71 Congress Street, with William Lowe as proprietor. The company advertised "Dustless cleaning of carpets, rugs, matting, etc., without removing from the floor," and "Don't take up your carpets; have them cleaned on the floor without pulling a tack. . . . " The company's territory included Cohoes, Watervliet, and Waterford.

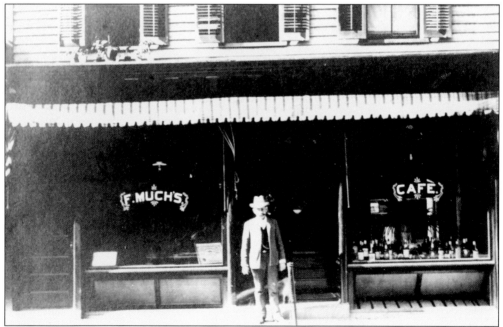

Fred Much poses in front of his café, located at 74 Mohawk Street. He, his wife Caroline, and daughter Edith Much (later Hawkins), all lived above the café in the 1900s. His wife prepared food daily for the free lunch that was available at the café.

This photograph of the J. H. Mitchell Hook and Ladder No. 1 was taken in October 1910 on Remsen Street in front of the Masonic temple. The fire department was demonstrating how the ladder could reach the top of the building. The fire company was housed on the corner of Oneida and Canvass Streets. The store on the first floor of the Masonic temple is the Golden Ball Dry Goods and Shoe House.

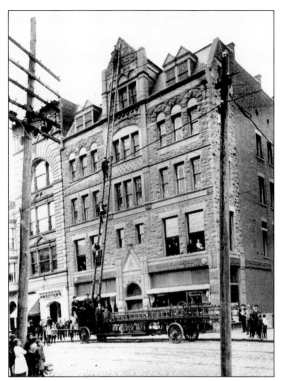

Alice Ann Courtois and Alfred F. LaMarche met at this 1908 performance at the Cohoes Opera House sponsored by St. Joseph's Church; the couple later married. The Opera House was located at 132 Remsen Street between the Masonic temple and the Cohoes Hotel. The five-story brick and stone building was erected in 1899 in the style of many New York City theaters. It featured vaudeville acts and could accommodate 1,400 patrons.

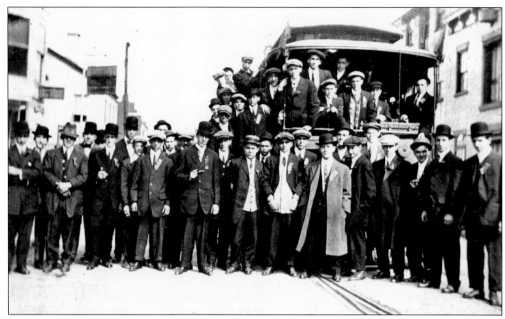

A trolley returns from an outing with a group of men wearing lapel ribbons earned at the event. The hats range from an informal cap, to the dashing straw skimmer, to the everyday fedora, and the formal derby.

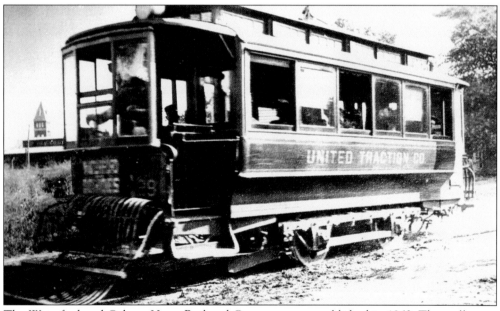

The Waterford and Cohoes Horse Railroad Company was established in 1863. The trolley car line joining Cohoes and Waterford opened in 1884. Its cars were painted green, so the route became the "green" line. At the peak of trolley service in 1923, it was said to be possible to travel from the capital district to Chicago by means of adjoining lines, with a 20-mile exception near Fonda, New York.

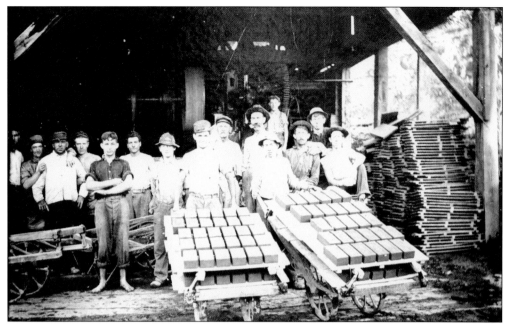

Workers in Carey's brickyard pose around 1910. Youngsters between the ages of 10 and 14 were among the work crew; they carried molded bricks into the yard for drying and firing. The brickyard was located on Reservoir Street, between the New York Central railroad tracks and the Erie Canal. The Carey Brick Company was in operation from 1901 to 1941. The company name was stamped on the face of the bricks.

The drugstore on the corner of White and Remsen Streets was operated by James Archibold when photographed here, around 1900. Brothers John and James Archibold were druggists—John with a shop at 18 White Street, James with one at 152 Remsen Street. John was also a physician. This shop later became Smith's Pharmacy, which remained in business until the 1970s. The building is now occupied by Lisa D's restaurant.

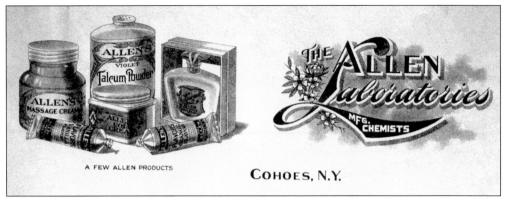

A FEW ALLEN PRODUCTS

COHOES, N.Y.

The Allen Laboratories were manufacturing chemists whose products included talcum powder, perfume, cold cream, and flavorings such as vanilla and orange. These items were probably sold at the city's early drugstores, including Calkins, Spillanes, Pellerins, and Archibolds.

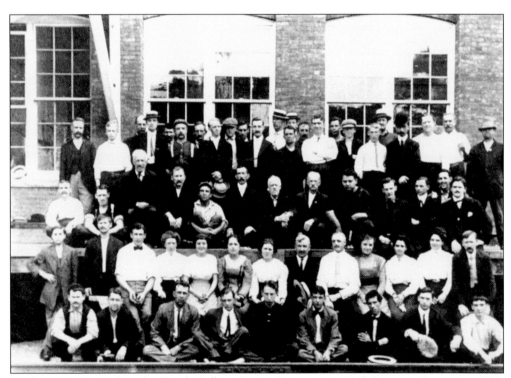

Workers are pictured at the Frank Gilbert Paper Company, at 465 Saratoga Street, in 1903. The Gilbert Mill produced wood pulp that was coarse and of dark color. The pulp was used as a base stock for wallpaper rather than writing paper. By 1919, the Frank Gilbert Paper Company had become part of the Hercules Paper Company, and in 1922 became Mohawk Papermakers, Incorporated. The company was reorganized in 1931 as Mohawk Paper Mills, Incorporated.

A FEW ALLEN PRODUCTS

COHOES, N.Y.

The Allen Laboratories were manufacturing chemists whose products included talcum powder, perfume, cold cream, and flavorings such as vanilla and orange. These items were probably sold at the city's early drugstores, including Calkins, Spillanes, Pellerins, and Archibolds.

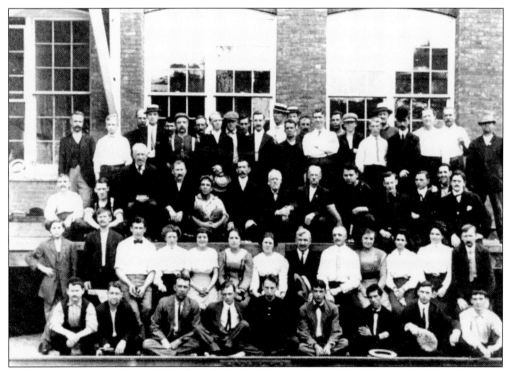

Workers are pictured at the Frank Gilbert Paper Company, at 465 Saratoga Street, in 1903. The Gilbert Mill produced wood pulp that was coarse and of dark color. The pulp was used as a base stock for wallpaper rather than writing paper. By 1919, the Frank Gilbert Paper Company had become part of the Hercules Paper Company, and in 1922 became Mohawk Papermakers, Incorporated. The company was reorganized in 1931 as Mohawk Paper Mills, Incorporated.

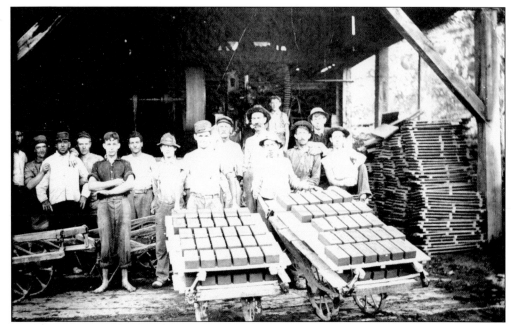

Workers in Carey's brickyard pose around 1910. Youngsters between the ages of 10 and 14 were among the work crew; they carried molded bricks into the yard for drying and firing. The brickyard was located on Reservoir Street, between the New York Central railroad tracks and the Erie Canal. The Carey Brick Company was in operation from 1901 to 1941. The company name was stamped on the face of the bricks.

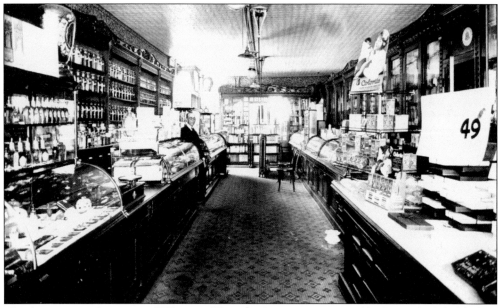

The drugstore on the corner of White and Remsen Streets was operated by James Archibold when photographed here, around 1900. Brothers John and James Archibold were druggists—John with a shop at 18 White Street, James with one at 152 Remsen Street. John was also a physician. This shop later became Smith's Pharmacy, which remained in business until the 1970s. The building is now occupied by Lisa D's restaurant.

This *c.* 1900 photograph is of Narcisse (1853–1949) and Edwidge (1861–1936) Gagnon, and 7 of their 14 children: Evelin, Edith, Jennette, Josephine, Henry, Alfred, and Joseph. Narcisse was a carpenter and built their home in 1887 at 137 Third Street on Van Schaick Island in Cohoes. The house stands today, and is still in the family.

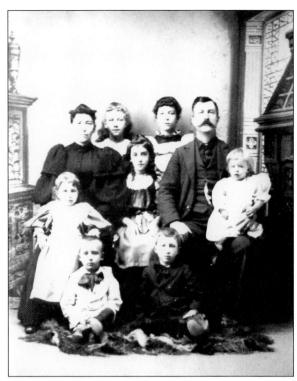

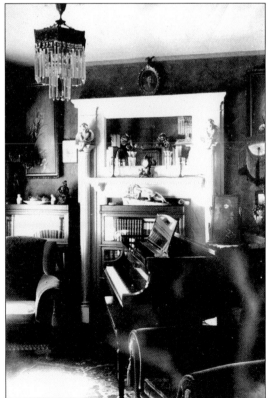

The house at 154 Park Avenue was the rectory for Sacred Heart Church prior to construction of a rectory on Forest Avenue. It was a private home before becoming the rectory. It was later owned by the Lavoie family and then by a Mr. Knorowski, who was a teller at the National Bank of Cohoes in the early 1900s. The family was well off since they had electricity during that time period.

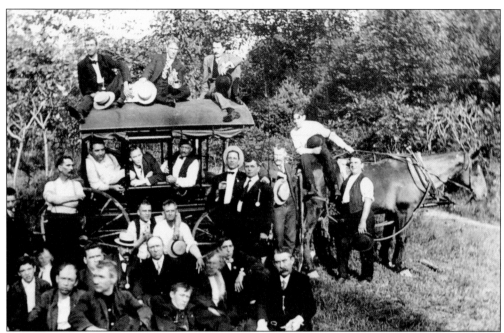

Seen here is a gathering of politically active Cohoesiers at Camp Wolf on the Mohawk River, not far from the Crescent Bridge, around 1904. The camp was owned by Charles Potts of Willow Street. He is standing by the horse.

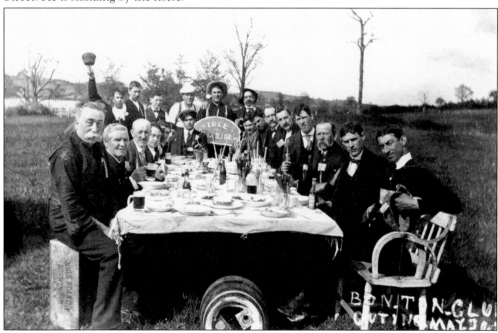

A Memorial Day outing of the Bon Ton Club is held at Camp Wolf on the Mohawk River on May 30, 1907. Charles Potts, camp owner, holds the Idle Hour sign. Cohoes politicos of the day met at the camp to strategize and party. The elaborate furniture includes a wooden crate from the John Stanton Brewery in Troy, New York, which was also the provider of the preferred liquid refreshment for the occasion.

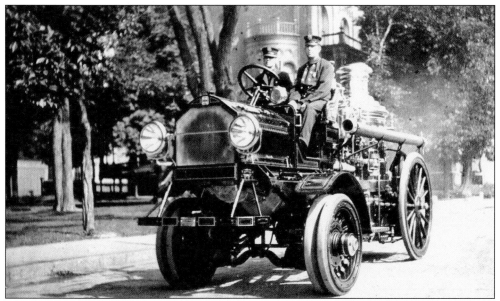

The 1900s Cohoes Fire Department Christie tractor (with front wheel drive) is seen pulling a steam pumper. The tractor eliminated the need for horses. The photograph was taken on Van Rensselaer Street, in front of St. Bernard's Rectory.

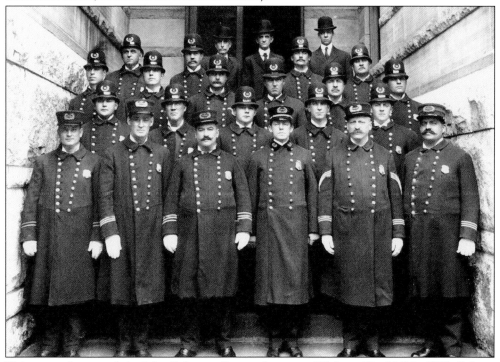

This group photograph is of the Cohoes police on the steps of Cohoes City Hall in 1908. Cohoes police were originally considered to be a precinct of the Troy district. The first Cohoes station house was at the corner of Remsen and Ontario Streets. In 1870, Cohoes organized its own police force and appointed the first police chief in 1896. The chief of police in 1908 was John Jameson, and the police sergeant was James Schofield.

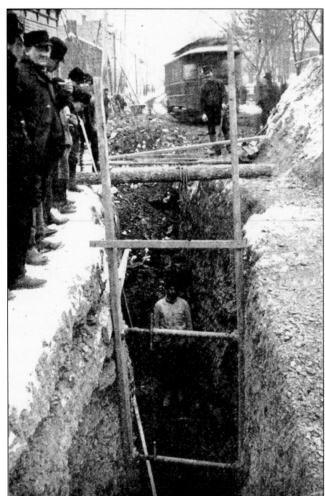

Seen here is the end of the 30-inch sewer at Mohawk and Saratoga Streets. Cohoes began an extensive sewer rebuilding project in 1896. At this time, sewer pipes were 30-inch oval shaped concrete pipes that had been in service since 1872 and that were in serious need of replacement. The 30-inch pipe was replaced by a 24-inch vitrified (glazed) pipe that cost $5.75 per foot, the most expensive sewer for its length in the city.

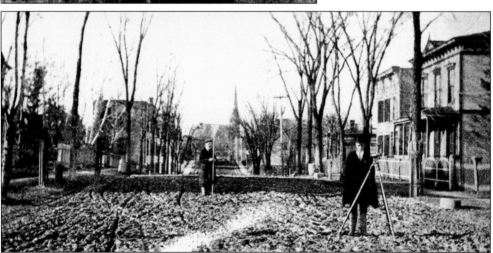

This photograph shows Grant and Vine Streets just prior to completion of this section of the sewer project in July 1900.

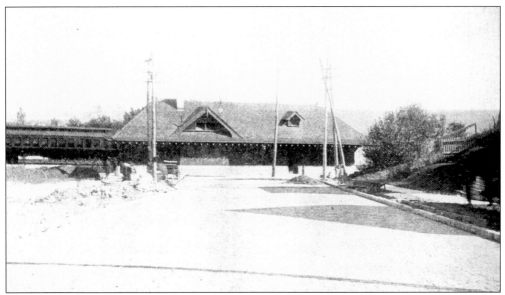

The New York Central Railroad opened this depot at the foot of Younglove Avenue on June 3, 1904. It replaced a station that was located near Trull Street. Trains used the tracks until freight service was discontinued in the 1970s. Passenger service on this line ended in the late 1920s. The Hudson-Mohawk Bikeway now uses the railroad right-of-way and there is an interpretive sign near this site.

This at-grade railroad crossing was very dangerous and cost several lives. The Troy and Schenectady Railroad was required to maintain two crossing gates, one for McElwain Avenue and the other for Younglove Avenue until the bridge at High Street was constructed. This project required building a retaining wall on the west side of the street to retain the high earth bank. That wall, although in need of repair, is extant today.

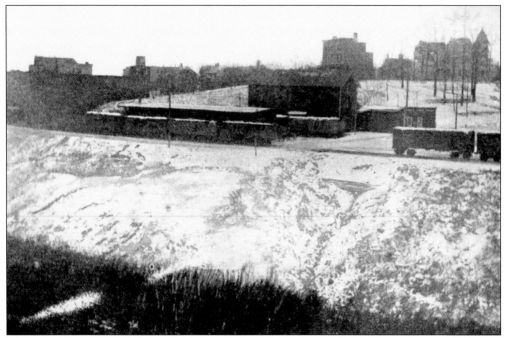

The ravine was part of the sewer contract, and this portion of the project began in 1900. It required 89,474 cubic yards of fill to complete at a cost of approximately $22,000. Cohoes and the New York Central Railroad Company paid George House $8,200 to move his warehouse to its new location on Garner and High Streets. This massive sewer project greatly improved the sewage system that had previously been in place.

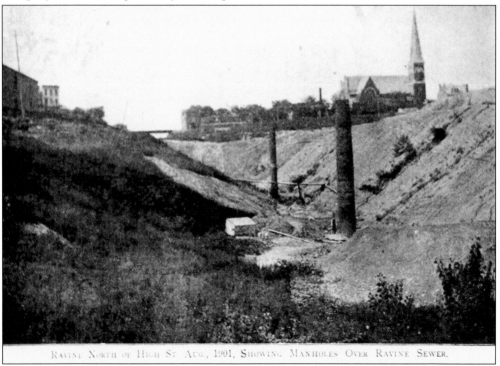

RAVINE NORTH OF HIGH ST. AUG., 1901, SHOWING MANHOLES OVER RAVINE SEWER.

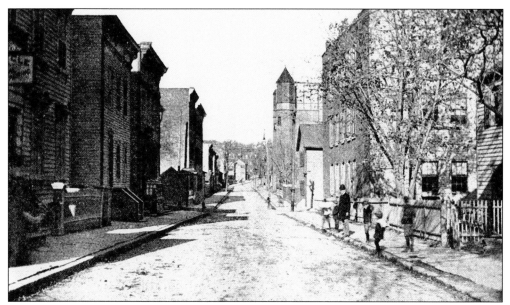

Because Lancaster Street was one of the early streets to get new sewers, this photograph shows what early asphalt looked like. Although it is not as smooth as today's asphalt, it was a tremendous improvement over the dirt that used to be this street.

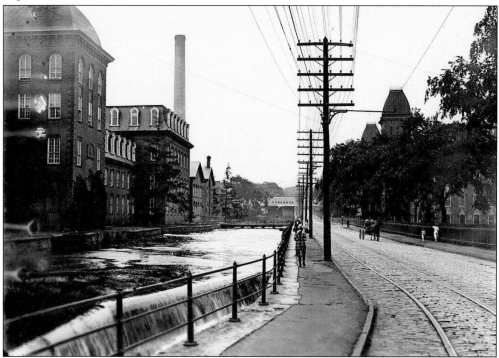

A view of North Mohawk Street, with Harmony Mill No. 2 on the left and Harmony Mill No. 3 on the right. By the 1870s, the Harmony Mills were one of the largest and most technologically advanced cotton factories in the United States. The Harmony Mills Company created a corporate community on what became known as Harmony Hill, which included factory buildings, housing, shops, and places for education and recreation for workers and their families.

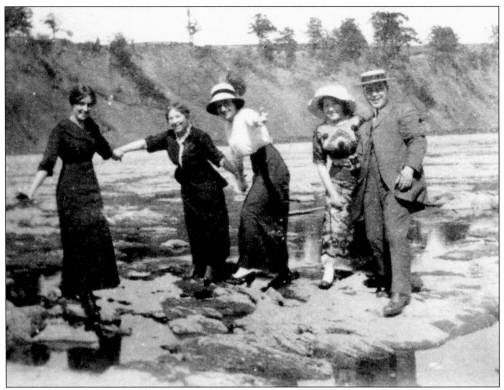

A group is on an outing below the Cohoes Falls at the beginning of the 20th century. The woman second from the left is Alma Lajeunesse. In midsummer and times of dry weather, the flow over the falls slows to a trickle, and it is possible to walk across the rocks at the base of the falls from Cohoes to Waterford on the other side of the river.

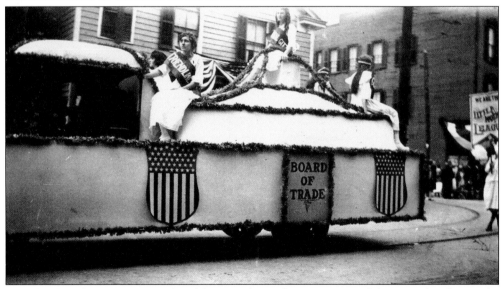

This is a float from a June parade celebrating the 50th anniversary of the city of Cohoes. The float carries a Board of Trade sign. The banner carried behind the float accompanied members of the Little Mothers' League.

Three

1923

2 June 1923

Dearest Sister,

You are certainly not the "La Petite Adelaide" I grew up with. I cannot believe this is your 10th wedding anniversary to Mr. J. J. Hughes. It seems such a short time ago that you and Johnny started dancing together. Yet, you have toured Europe and shared the American stage with James T. Powers, Eddie Foy, and Charlotte Greenwood all under producers such as Lee Shubert and B. F. Keith. Can you believe the Cohoes Music Hall has been closed up for almost 20 years? Does Charlotte still own the home she bought next to you in Bensonhurst, Brooklyn? Has anyone had a longer run at the Palace or do you still hold that honor? So many questions. I should fill you in on Cohoes.

Mother, as am I, is still distressed over Father's death in March. Family is so important to her. Our dear nephew visits regularly and still talks about leading the Egberts High School hockey team into the Eastern New York interscholastic hockey championship in 1912. He is helping celebrate the 13th anniversary of the Harmony Athletic Club baseball team which was originally organized in 1910. Through the years, you will remember, the team provided semi-pro players for many leading teams. The 1910 team included the Potts boys—Edward, Harold, and William. Do you remember the Potts family? They always ask after you. If it is not hockey, it is baseball with our nephew. He still wishes that he was on the Cohoes White Stars team when they were the 1921 champions.

Mother also remembers the many other cherished friends and relatives we lost in the big war. She still places flowers on the Honor Roll that they installed in September 1919. She goes every month without fail. She still regularly writes to Rev. Michael Foley. He was the war hero who was honored several times. The only thing she speaks of more highly than the parades and honors given our fighting men is when she sings your praises. She never mentions that the stagehands nicknamed her "La Grande Marmalade" as a send up of your original stage signature. (Of course, I have never told Mother about your court appearances, when you, shall we say, disagreed with some of the chorus girls.)

Thank you letters are still being received by the women, young girls, and older children from the Harmony Hill area who knitted squares that were made into blankets for the soldiers during the World War. I still have the write-up you sent from the New York newspaper when your needles were doing the same thing. Those letters are being displayed by the Red Cross Unit that

37

was started in November 1917 by the girls of Egberts High School, among whom were Thelma Jones, Margaret Thompson, Mildred Stiles, and Edith Brown.

Cohoesiers always pull together during important times. Do you remember that in 1918 the Cohoes Armory was a temporary hospital for victims of the influenza epidemic? Or that the armistice ending the World War was announced to Cohoesiers by 21 blows on bells of the fire alarm system, repeated three times? It was 3:00 a.m. on November 11, 1918, and the celebration lasted for 24 hours. The bells and factory whistles all over Cohoes were joined by those in other communities. I had shivers up and down my spine. Mills and other businesses closed and thousands assembled in front of city hall to hear Mayor Michael J. Foley and others speak. There were multiple parades and saloons did a booming business. The *Cohoes Dispatch* called it the "greatest day in Cohoes history." It would have been greater if you were here to join us but you were busy with your long run at the Palace Theater.

If you write to anyone, make sure you do not use Bowery Street, they changed its name to Masten Avenue.

Mother and I are entering a contest being held by the Cohoes Power and Light Company. They are looking for a new advertising slogan that expresses the value of gas or electricity. It has to be 10 words or less. Any ideas? You think well on your feet. It better not have to do with the electric trolley, with this strike occurring.

The Cohoes Community Orchestra is performing next week with Margaret Dexter Babbs, contralto. Can you make it up? We just saw Mary Pickford in *Tess of the Storm County.* Mother loves her.

The weather is so beautiful in early June and the parks in Cohoes are bursting with the colors of a painter's palette. Sunset Park is where Cohoes's first reservoir stood until 1914. Depot Park was created at the foot of Imperial and Younglove Avenues, just doors from our old house that Father built in 1890.

<div style="text-align:right">Your loving sister, Helen</div>

This young woman, Thelma Jones, represented one of the Allied Powers, Great Britain, in a tribute to World War I soldiers. She was in an April 17, 1918, pageant by Egberts High School students to raise money for the Red Cross. The photograph was labeled "To Arms For Liberty." Can you find her on the stage in front of the honor roll in the photograph below?

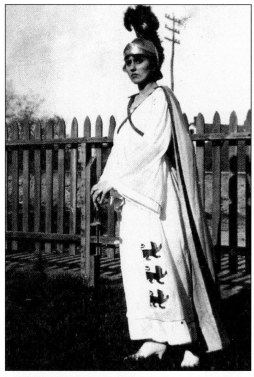

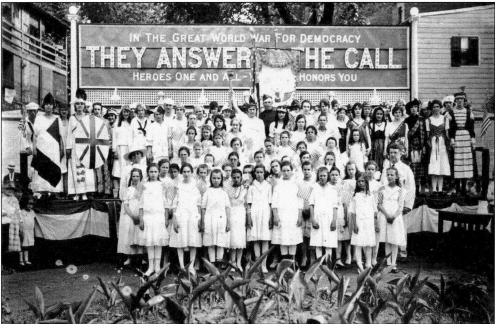

This semi-circular wooden honor roll, shown here at a Flag Day celebration on September 14, 1919, listed the 1,453 Cohoesiers who served in World War I. It was erected on Mohawk Street where the post office is now located. The $1,132 for the project was raised by popular subscription. The structure was later moved to Ontario Street where it fell into disrepair and was taken down during the Depression years.

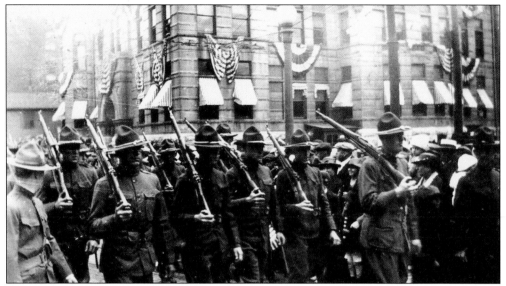

A company of World War I soldiers (members of the 105th United States Infantry) is marching past Cohoes City Hall to the Cohoes Armory for a reception to celebrate their return from the war. Maj. T. C. Collin organized the reception, which included a brief address by Mayor Foley.

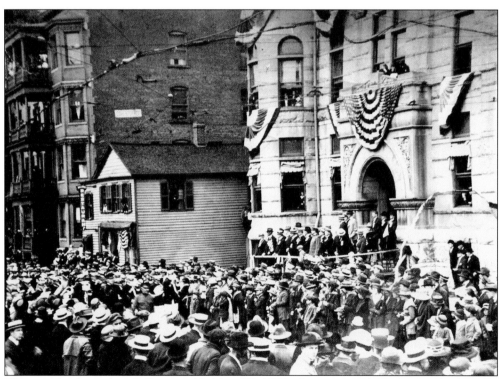

This crowd in front of city hall is assembled for a World War I victory parade in 1918. Michael J. Foley was the mayor. Following "the war to end all wars," many turned out to show their support for the returning troops. Cohoes City Hall proudly shows its bunting from the third and second floors. Note the straw boaters worn by the men in this photograph.

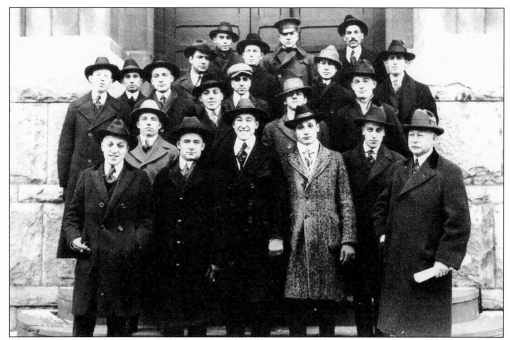

World War I soldiers stand in front of city hall, in 1918, having just been inducted into the Army's 305th Infantry. Charles Rowan is in the front row on the right side. He was among the first Cohoesiers to lose his life in World War I, killed on June 3, 1918. His portrait was painted, as one of the city's early casualties of the war, and given to his family. The painting has been donated to the Spindle City Historic Society.

World War I soldier Harold Potts is on leave at his 68 Willow Street home, with brother Edward on the right, and an unidentified gentleman with a beard on the left. This was a company house built for mill workers where the family's mother and father, nine children, an uncle, and two cousins lived in a four bedroom flat. Such crowded conditions were not unusual at the time as families took in boarders to earn extra income.

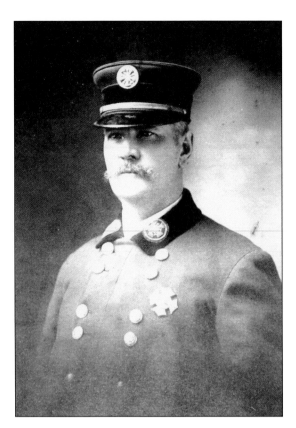

Thomas C. Collin was the Cohoes Fire Department chief. He was also chief of police, as well as commander of Company B in the National Guard.

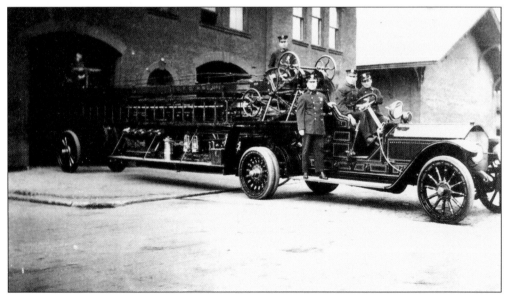

Shown here is the 1920s hook and ladder truck of the Cohoes Fire Department, with Preston McGarry standing on the running board. This was the Oneida Street firehouse, the main firehouse for the mills. The site is now an empty lot.

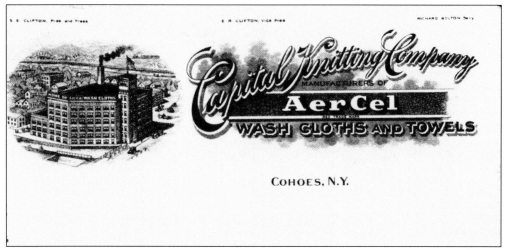

Capital Knitting Company

MANUFACTURERS OF

AerCel

WASH CLOTHS AND TOWELS

COHOES, N.Y.

The Capital Knitting Company made AerCel washcloths and towels. The company was housed on the second floor of the four-story Parsons Knitting Mill Building at Remsen and Factory (Cayuga) Streets. R. S. Clark and Sons Printers, and the Cohoes Wet Wash Company, were on the first floor, and Tim and Company, a laundry, was on the top two floors of the building. The building had a catastrophic fire on December 12, 1913.

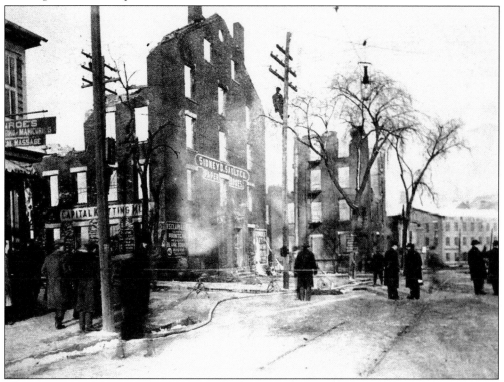

This is a view of the ruins from Remsen and Factory (Cayuga) Streets following the fire. The fire spread rapidly, engulfing an area from Factory Street to the bridge spanning the Cohoes Company's canal, to Courtland Street. While fighting the blaze, fireman George Chabot fractured his right leg when he fell through a scuttle hole. During the excitement and confusion of the conflagration, someone stole a fire hat and rubber coat belonging to Steamer No. 11.

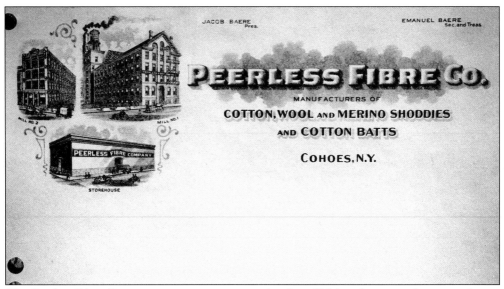

The Peerless Fibre Company was a successor to the Carroll Manufacturing Company. It was located at Egbert's Mill, at 301 Ontario Street. The mill was built in 1863 by Charles H. Adams, the first mayor of Cohoes. Peerless Fibre was in business from 1904 until a fire in February 1957. They advertised "Cotton Batts, Wool, Merino and Cotton Shoddies—Mill wastes bought for cash."

Steadfast Mills were manufacturers and importers of underwear and hosiery. They were first located at 6 Remsen Street (1918–1920) and then relocated to 12 Remsen Street in 1922 until 1951, when it became Cohoes Fiber Mills Incorporated, garnetters. Garnetting is when individual cotton fibers of various lengths are laid into a web by combing. The webs are then layered to produce cotton batts of specific size and weight.

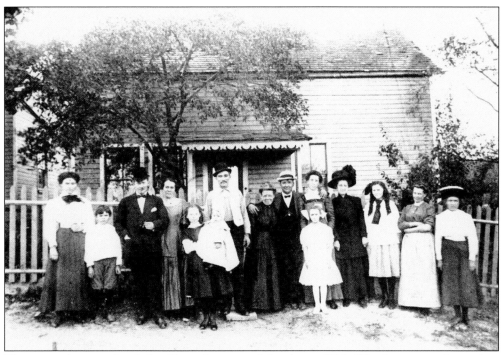

This is a photograph of the Hines home and family in 1913. The house was located at 36 James Street.

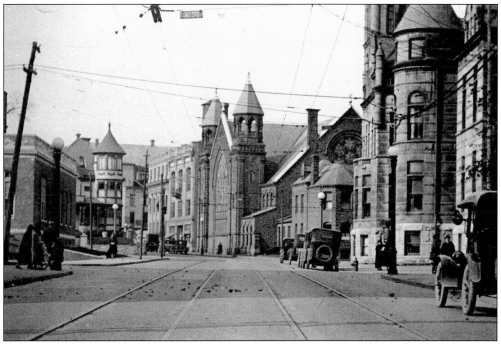

Here is a view up Ontario Street, showing city hall, the Silliman Memorial Church, and the post office. St. Bernard's Convent was located on the site of the present HSBC Bank. St. Bernard's Convent burned on October 24, 1939, and the nuns were relocated to Cayuga Street.

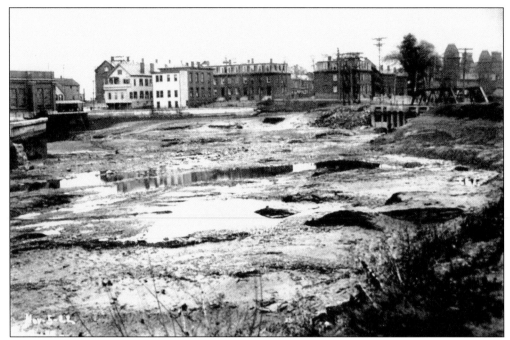

The power canals serving the mills were drained periodically for cleaning and maintenance. This occurred during the late fall, as shown in this 1922 photograph of a forebay and concrete dam, and for a week during the summer months. During the "week the water went out," mill employees went on (unpaid) vacation. Some workers got married during this brief respite from the dawn to dusk routine of work at the mills.

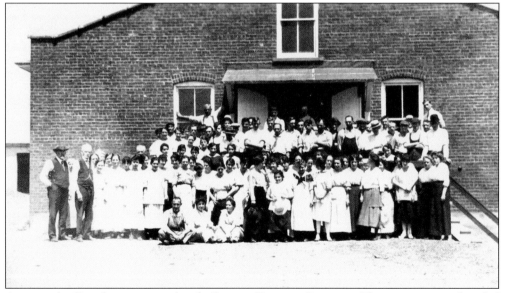

A group of mill workers is pictured at the Putnam Knitting Company. This company was founded in the 1890s by John Henry Murphy. It was located on Jackson Avenue and made baby clothes. John Henry's sons, John Harold and William Eighmey Murphy, took over the business in 1936 after his death. When William and John retired in 1965, the business was run by Leroy L. Lewis. The company stayed in business until the mid-1990s.

This *c.* 1916 photograph shows a graduation class at the Cohoes Hospital. Emeline Cote (seated, second from left) is the only one positively identified. The orderly (male nurse) may be Dougal Dollar. Mrs. Fletcher, the head nurse, may be on the left. Other nurses in the hospital at this time included: Joyce Douglas, Ms. Winters, Mrs. Bentley, and Alice Hebert, the wife of Dr. Raoul Hebert.

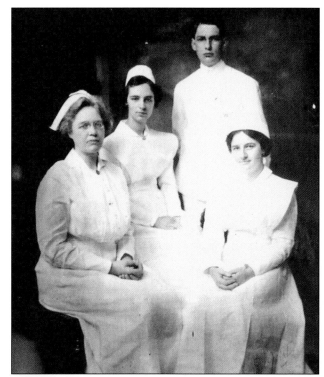

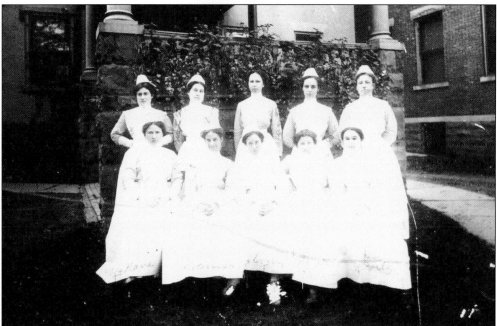

This is a nursing class from the Cohoes Hospital around 1911. The first Cohoes Hospital was established in February 1872. This institution lacked financial support and closed. The second hospital was built on the John Scott property on Main Street and opened in 1892. The Cohoes Hospital trained its own nurses, with nurse candidates boarding at the hospital. Their dormitory was located in the top story of the original three-story brick building.

Bill Sorel (second from left) is pictured with some friends in front of a barn around 1915. A horse noses into the photograph on the left. An automobile, probably the horse's replacement in transport, is also in the garage. Sorel later became a Metropolitan Life insurance salesman and lived with his family at 68 Willow Street in worker housing.

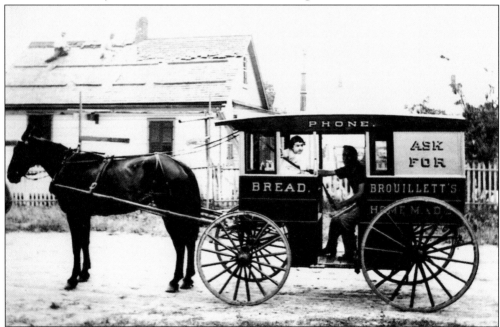

The Brouillette family prepares for a bread delivery. The bakery, run by Honore Brouillette and later by three of his children, opened in the mid-1880s. They advertised "Tea biscuits, buns, crackers, corn muffins and French rolls every day." The shop, at the corner of Charles Street and Willmer Avenue, remained in business until 1912. Two of the daughters who ran the business, Lena and Rita, also worked in the mills.

48

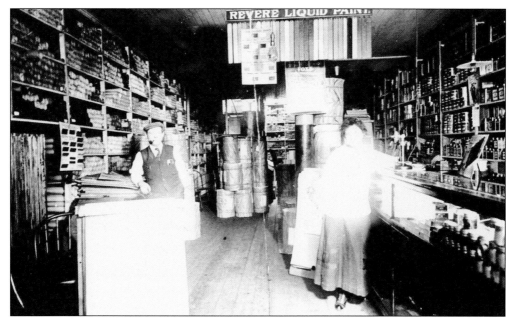

In 1908, Fred and Pierre LaMarche were painters, living at 34 Congress Street. By 1923, Pierre LaMarche and his son Wilfrid established LaMarche Paint and Paper at 34 Congress Street. The proprietor was Peter "Pierre" LaMarche. The store was on the first floor, and the second floor was Pierre's residence. His son Alfred Sr. and his family lived on the third floor. The site is next door to the Eagle Garage.

In 1926, Pierre LaMarche and his son Wilfrid began the Cohoes News Company. By 1929 they were selling paints and oils, continuing this business until 1937. In 1934, Wilfrid became a confectioner, based at 48 Remsen Street, moving to 44 Remsen Street in 1938. By 1944, the business was a news and tobacco store, located at 65 Remsen Street. It remains in business as a variety store.

Confectioners Edmond Tremblay and George Fortin stand in front of Fortin and Tremblay at 93–95 Howard Street, near Main Street. They ran the business from 1919 to the early 1920s when John Fitzgerald opened his shop there. Fitzgerald's operated until 1947. After shows at the Cohoes theatres, the line waiting for ice cream at Fitzgerald's would wind around the corner.

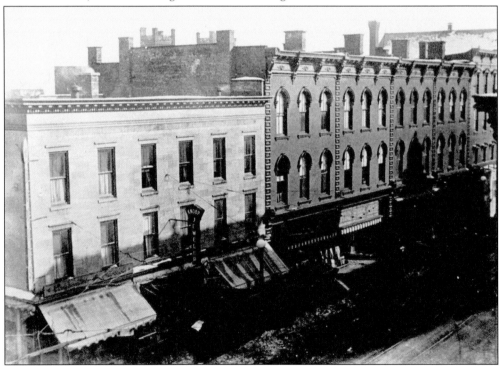

Knoop Jewelers on Remsen Street is shown here around 1920. The Knoop family operated a jewelry and watch making store from 1886 to 1951. Theodore Knoop opened his first store in 1887 at 29 Remsen Street and later moved to 97 Remsen Street. In 1908 Louis R. Knoop went into the business with his father. From 1918 to 1951, Louis R. Knoop operated his store at different locations on Remsen Street.

This is a rear view of the addition to the Cohoes Company Gate House on June 4, 1922. The Cohoes Company, incorporated by the New York State Legislature in 1826, was the forerunner of modern utility companies. The company first constructed a dam across the Mohawk above the falls in 1831. In 1865, a solid 1,443-foot masonry dam was built along with a gate house containing the head gates.

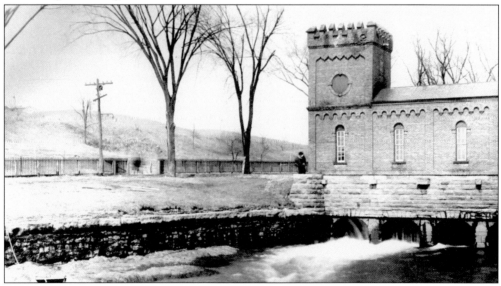

The Cohoes Company Gate House was designed by architect David Van Auken, who designed Harmony Mill No. 3. The gate house was 218 feet long. In later years, the central tower of the gate house was removed, as were the hipped roofs of the side towers. In 1911, when the power canal system was replaced by hydroelectric power, a one story brick extension was added to the building to control water flow.

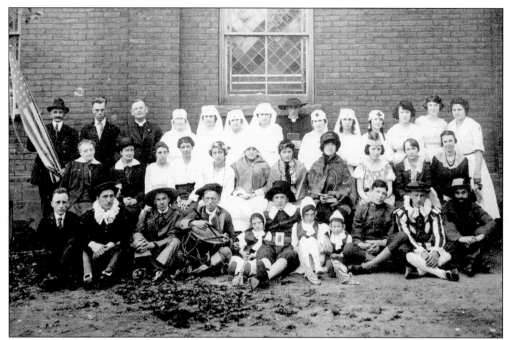

This group from St. James church was performing a pageant near West End Park in 1919. In the back row, the sixth person from the left is Thelma Jones Filkens, who married James Rowan. The St. James Methodist Episcopal Church was the successor to the Park Methodist Episcopal Church. It was organized in April 1881. The church was built in 1881–1882 and replaced in 1894 with a new building on McElwain Avenue.

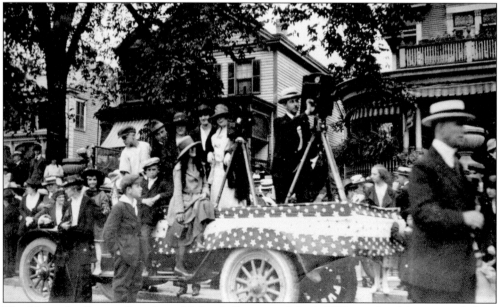

The Marra family parading down Mohawk Street on July 4, 1920, on the delivery truck from their grocery business. Members of the Marra family seen here are James, John, Rose, Paul, Frank, Agnes, Frances, and Ida. The photographer on the float is Walter H. Hilsinger of 105 Remsen Street.

Women are seen walking north on a hike to Peebles Island on June 11, 1920. The LeRoy Knitting Mill is on the left; Rensselaer Valve is on the right. Rensselaer Valve, established in 1853, manufactured valves, water gates, and Corey fire hydrants. This was one of the firms that made the region (Cohoes, Troy, and Waterford) a nationally known center for the manufacture of valves and fire hydrants. Riverwalk Apartments stand on the site today.

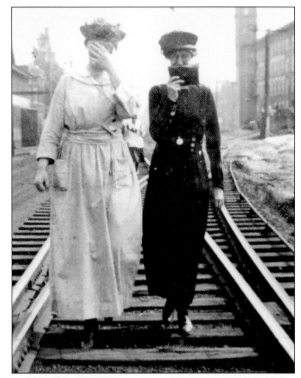

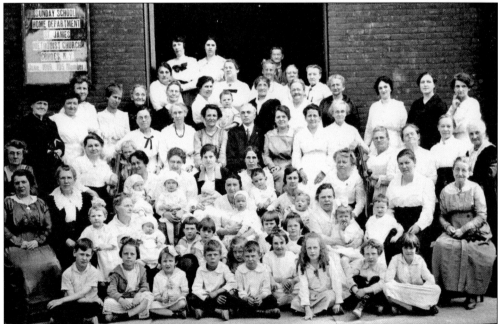

St. James Methodist Episcopal Church Sunday school is seen here, around 1919. The St. James Methodist Episcopal Church (as the Park Methodist Episcopal Church) dates to the early 1870s, when a small chapel was built at the corner of Masten Avenue and Cherry Street. At the time of this photograph, the church was located on McElwain Avenue. This church was destroyed by fire on July 4, 1982. The congregation now worships at a church on Simmons Avenue.

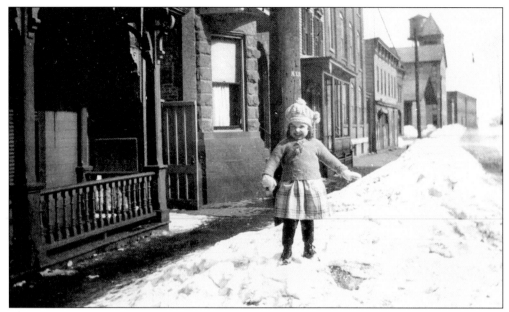

This little girl named Kelly is seen standing on a snowy Oneida Street in 1919. A water tower in the background supplied water for the Hope Mill as well as water for its sprinkler system in case of fire.

This picture was taken at Yvonne Blais Richardson's christening. The christening gown dates from 1890 and has been handed down from generation to generation. Yvonne's great-granddaughter was the latest baby to wear the outfit. The photograph dates from around 1922.

Joseph W. Ekiert sits on a rocking horse in August 1923. Parents Walter and Nellie lived at 73 Saratoga Street in the 1920s, and then relocated to 66 Park Avenue on Van Schaick Island in the 1930s. Walter worked at the Harmony Mills in the 1920s and later became a car repairman for the D&H Railroad.

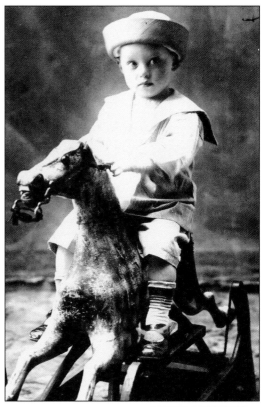

Joseph Marra's delivery truck is seen here, around 1920. Joseph Marra arrived in the United States from Italy in the 1880s, heading west from New York City to Wyoming. He eventually returned east and settled in Cohoes. He started a variety store in Cohoes in 1890, and later a fruit store. Marra's store carried both fresh and canned produce; many of the products he sold were not widely available elsewhere in the area.

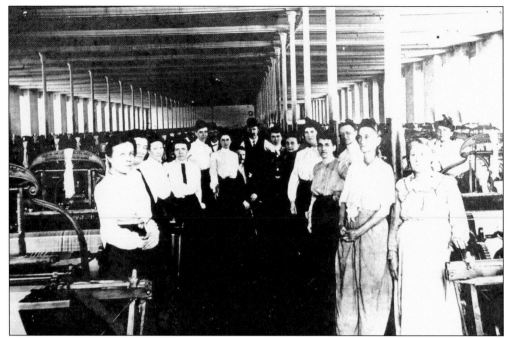

This group of mill workers is posing in front of their weaving machinery. Notice the predominance of women workers. Approximately 10,000 workers were employed in the mills in Cohoes during this time and approximately 70 percent of them were women.

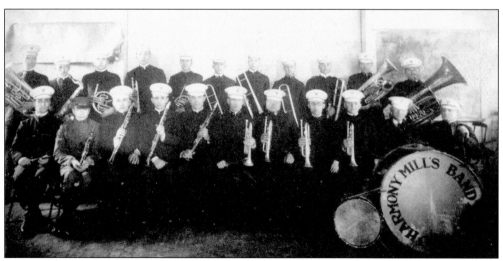

Frank Gebosky Sr. was a trumpet player and conductor of the Harmony Mills Band in the 1920s. He is seen fourth from left in the second row of this photograph. He sold insurance for Metropolitan Insurance Company door to door and collected the premiums on a weekly basis for those who could not afford larger payments. Many of the band members were workers at Harmony Mills.

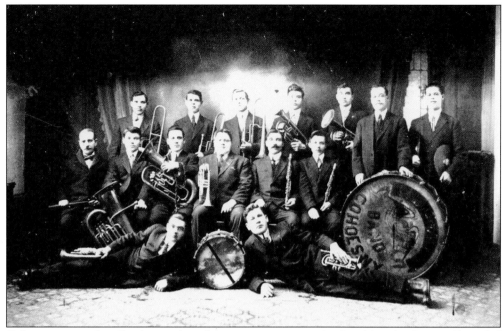

Cohoesiers were bandleaders and performers in many popular local bands. George Slater led the Troy-based Doring Band, and Pat Santoro was the leader of the Italian Band of Troy. Michael and Romeo Mitri also played in the Italian Band. Other Cohoesiers playing in local bands included Frank Kendricks, Charlie Kendricks, Tommy Williams, Charlie Holden, and Frank Gebosky Sr.

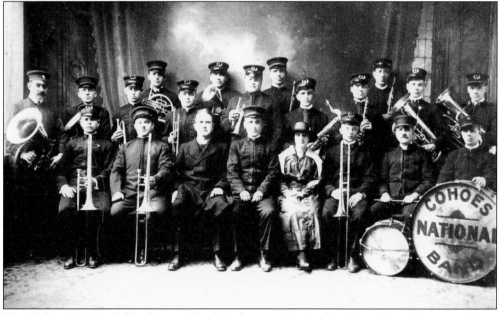

The Cohoes National Band poses for this photograph. At this time, when there were fewer forms of popular amusement, almost every group or organization had its own band. The bands played at civic events, performed in parades, and provided entertainment for parties, dances, and other celebrations.

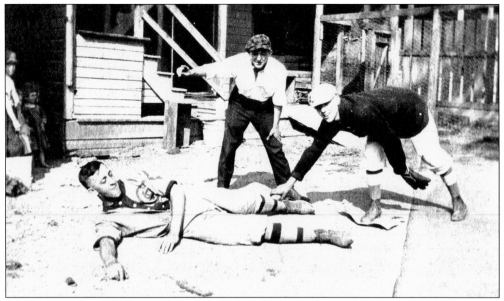

On the ground and "called out" at base is Sylvio Bernard. Notice the piece of paper serving as a base. Many of the city's industries had sports teams, including the Cohoes Power and Light Corporation, for which Sylvio played. The Cohoes Power and Light Corporation erected a hydroelectric plant in 1915 after purchasing water power and property rights from the Cohoes Company. By 1923, they supplied power to all Cohoes industries.

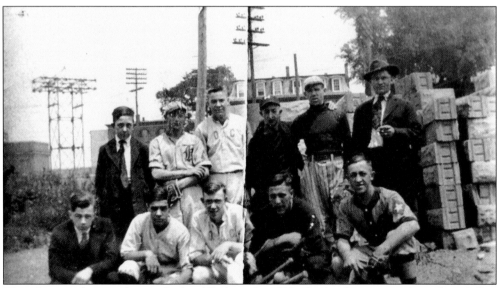

This photograph was taken in Orchard Park in the 1920s. In the first row on the right is Sylvio Bernard. Some of the men are dressed in mismatched baseball uniforms. The building in the rear was Harmony Mills worker housing. The park was later called Devlin Street Park until it was renamed Craner Park in 1974 after Robert Craner, who was a prisoner of war in Vietnam.

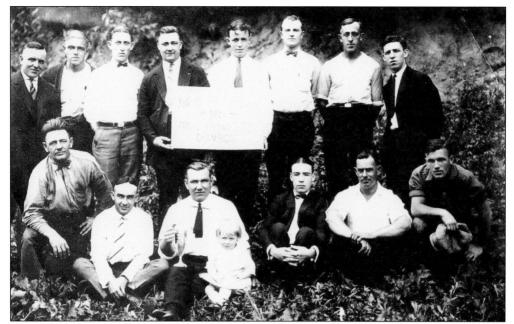

These are the 1924 softball league champions from Cohoes Power and Light Corporation. Standing in the top row are the Lavigne brothers (Alex, Edmund, William, and John), a fifth brother holds the trophy. Standing second from right is Sylvio Bernard. Kneeling in the first row on the left is Wallace Riberdy. The Cohoes Power and Light Corporation succeeded the Cohoes Company, organized in 1826 by Erie Canal engineer Canvass White.

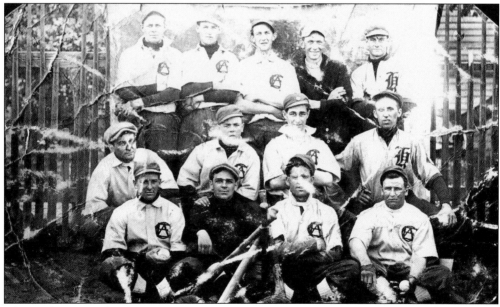

The Eagle A. C. of Cohoes won many games in 1913. In this photograph, from left to right, are (first row) N. Lagasse, Charles Lagasse, William George, and Jerry Lagasse; (second row) John Howarth (who became a police justice in Menands), Omer Lagasse, Peter Lange, and Foster Demers; (third row) Harry Goss, Ed Kennedy, Daniel Kennedy, Charles Ashworth, and Hiram Heywood.

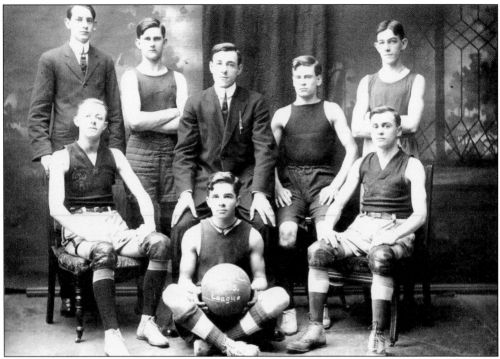

The Reds basketball team of the Cohoes Sacred Heart Club earned first place in the league after defeating the Blacks at St. Joseph's Hall in March 1913. The only team member positively identified is Edmond Tremblay, who stands at the far right of the back row. The last names of other team members were Gendron, Galipeau, Jarie, and Bouchard. The photographer was Walter Hilsinger who had a studio and home on Remsen Street.

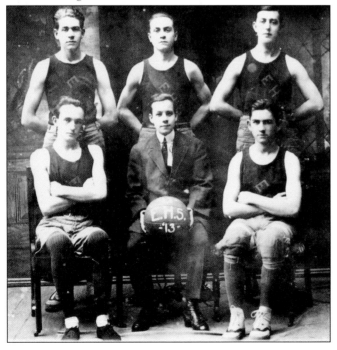

Egbert's High School Basketball team in 1913 consisted of ? Calkins, ? Nealand, ? Plotkey, Morton Valley, ? Vandecar, and ? Conway. Egberts Institute was located on the corner of White and Mohawk Streets. It was established in 1864 by Egbert Egberts, a prominent Cohoes industrialist and philanthropist. The building served as the city's high school from 1868 to 1920 when Cohoes High School (currently Cohoes Middle School) was opened on Columbia Street.

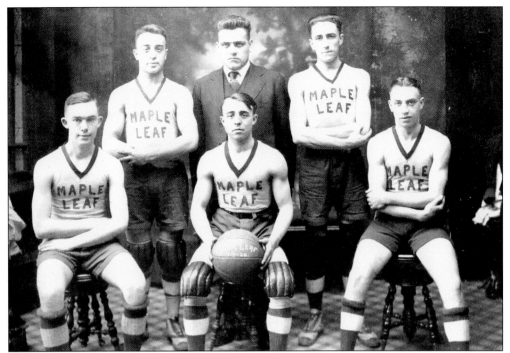

Maple Leaf basketball players in the 1919–1920 season are shown with their coach. The team name reflects the French Canadian origin of team members. Many French Canadians worked in Cohoes, the majority in the city's mills. Specific recruitment efforts were made to bring French Canadians, primarily from Quebec province, to work in the mills.

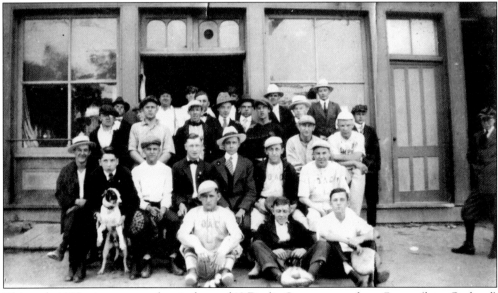

This early-1920s picture was taken in front of 12 Devlin Street, across from Craner (later Orchard) Park. The building was known as the Pool Room and was removed in the 1970s. Sitting second from the right in the second row is Sylvio Bernard. The letters OAC on the jerseys may have been the Orchard Athletic Club, as each of the city neighborhoods sponsored baseball teams.

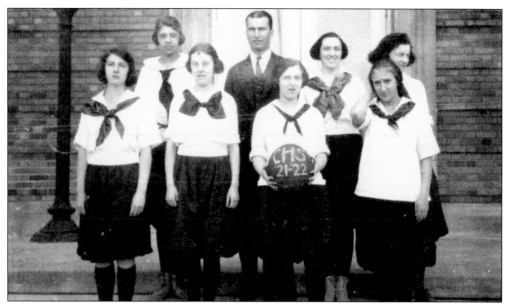

The 1921–1922 Cohoes High girls basketball team poses for a picture. In the days before women's athletics was popular and widely accepted, there were few girls' teams, so players had to be content with "a few and far between" playing schedule or intramural games. Notice the girls' bloomers. By the close of the 1920s, team uniforms had become more suited to vigorous sports, with the girls wearing shorts or short skirts and short-sleeved shirts.

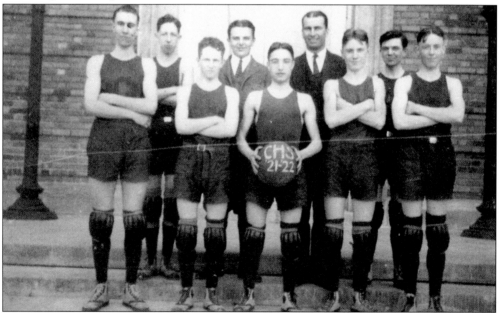

Here is the 1921–1922 Cohoes High boys basketball team. This team played against such schools as LaSalle Institute and Albany High School, and also against the freshman squads at Rensselaer Polytechnic Institute and the State College, known as the University at Albany. One of their other opponents was St. Bernard's Academy. This long-standing friendly rivalry would continue after St. Bernard's Academy became Keveny Memorial Academy. It lasted until the close of Keveny in 1986.

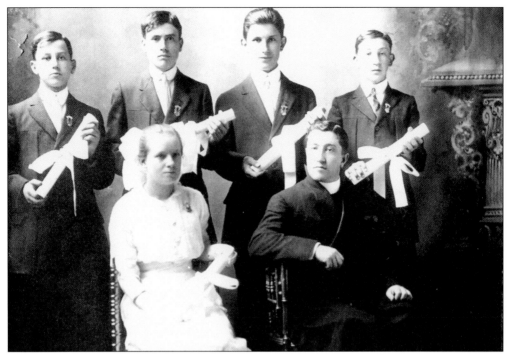

The 1914 graduating class of St. Marie's School poses for this photograph. The original school was built in 1900 at 145 Vliet Street, and was established before St. Marie's parish so that the neighborhood children would not have to negotiate the treacherous winter streets to attend parochial school at St. Joseph's. From left to right are (first row) Marguerite Bialeski and Rev. George Gagné, the first pastor at St. Marie's; (second row) Napoleon Derocher, Alphonse Alix, Leo Favreau, and Alfred Lanoue.

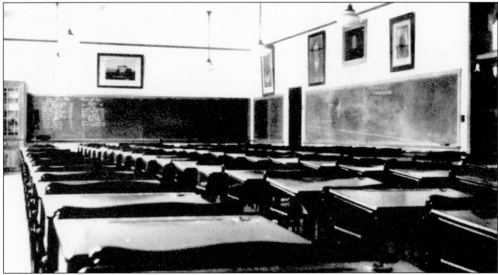

This shows one of the Cohoes High School classrooms in the early 1920s. This was taken shortly after this new school opened and the staff and students had moved into the building. Note the number of double desks in the classroom. The city of Cohoes took great pride in this new school building.

Charles "Pop" Wheeler is in his office in Cohoes High School. He began his career as principal of Egberts High School in 1914 and went on to be principal of Cohoes High School until 1946 when he retired. His retirement dinner was held at the Cohoes Elks Club on August 5, 1946.

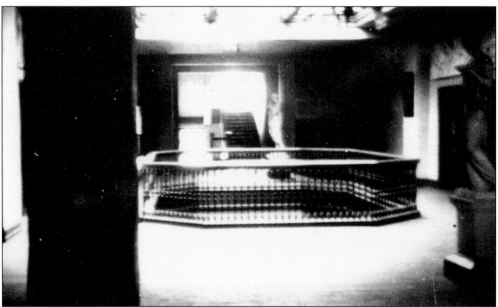

Shown here is an interior shot of the Egberts Institute balcony. The Institute was founded in 1864. Egberts High School was established in 1868 and the first class graduated in 1872. The last class graduated in 1920, and the school then relocated to Columbia Street in what is now the Cohoes Middle School. Note the statuary arrayed around the rotunda.

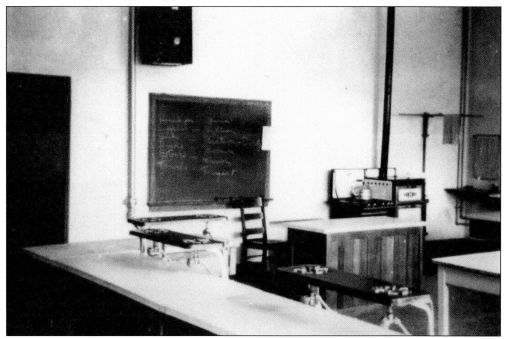

Here is the Cohoes High School home economics classroom. Note the high side oven, the gas stove tops, and the assignments for clean up and other tasks noted on the blackboard. This room was clearly intended to provide guidance to students on the intricacies of the home and the running of a household.

This picture shows the Cohoes High School faculty sometime in the 1920s. They stand proudly in front of the main entrance to the school with principal Charles "Pop" Wheeler. Notice the white shoes on some of the male faculty; quite the style statement for the day.

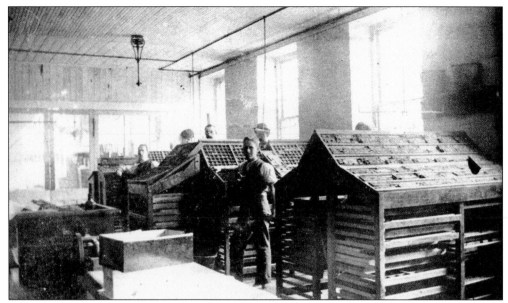

Seen here is the typesetting room at R. S. Clark and Son Printers. The printer was located on the first floor of the four-story Parsons Knitting Mill Building at Remsen and Factory (Cayuga) Streets until a fire on December 12, 1913. After the fire, the printers reopened across the street on December 23 of that same year. They remained in their new office at 51 Mohawk Street until 1937.

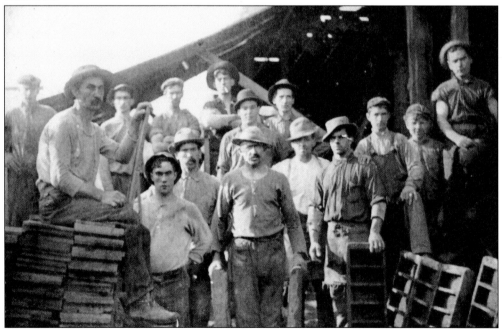

This c. 1910 photograph of Carey Brick Company shows Louis Grandchamp (center) holding two brick molds. The man to his left is Cyrus Yarter. The Carey Brick Company, in existence from 1901 to 1941, was one of many brick companies established in Cohoes. The industry developed from its early days, where bricks were hand struck, into a technically sophisticated process that met the intense demands of a flourishing mill town.

Four

1935

My dearest Addie,

I haven't called you Addie since we were children. I remember so vividly watching you dance on the sidewalks of Troy to the music of a hand organ. They sent us to dancing school early, and it was there, I believe, that the idea of going on the stage was first put into your head. How dramatically our lives have changed since Mother died in 1927 and J. J. only eight months later. My best wishes on your 53rd birthday. I think I am the only one who knows your actual age. You changed it so often. I am glad you have the dancing school to keep you busy. Have Vernon and Irene Castle ever stopped teasing you because you named your dance school "Bensonhurst by the Sea" as a parody of their school "Castles by the Sea?"

Does that question mark go inside or outside the quotation mark? I know that Miss Della Jones and Miss Georgie Nicholls taught us well at the White Street School, but I never seem to remember. Did I ever tell you in my letters that Egberts High School is no longer in use? A new school has been built on Colombia Street near West End Park. (You might remember that West End Park was a Civil War Cemetery many years ago.)

We really had some excitement recently. The gangster, Dutch Schultz, hid out in the old Harmony Hotel! He was not the only important person in our fair city. Clarence Darrow, the famous criminal lawyer, lectured at the Cohoes Educational Forum the night of January 11, 1934, on "Crime, its Causes and Prevention." What are your feelings on Prohibition? The campaign against the sale of poison liquor in Cohoes was launched by order of Police Chief John E. Burke. I find it hard to believe that some people are still rabid about this topic.

Politics never interested me but last year's election is still on everyone's mind. It was considered one of the wildest in Cohoes politics. The Fusion Party challenged Mike Smith's Democratic machine. Vandalism occurred on both sides and on election night, hired thugs from each party, armed with clubs, blackjacks, and revolvers, surrounded the polls. The Fusion Party candidate, John J. Morrissey, won by 246 votes.

Cohoes has been so badly affected by this terrible Depression. Unemployment figures are at an unbelievable high. So many of the businesses that we grew up with are no longer here. The few that are left are functioning with a skeleton crew, and so many people still need to find work. My heart goes out to them. Now our food sources are being affected with the Dust Bowl in the west. Have you seen the photographs? Hopefully President Roosevelt's New Deal will help all of us.

Unfortunately, one group in Cohoes has far too much to do. The Red Cross is burdened with the task of having clinics in Cohoes City Hall to administer treatments to protect the city from a diphtheria epidemic. Several copies of that new game "Monopoly" by the Parker Brothers were donated to help pass the time down there. People are saying it is the "next best thing since sliced bread" for passing the time, and sliced bread has been available at the grocers for five years!

St. Marie's is celebrating its 29th anniversary and I have been invited to the dinner. I am not sure if I should accept or decline. I do not know who else is attending besides Eldora E. Marsolais and Thomas Berry Kiely. Did I mention they were married in June? Thomas is now the editor of the *Cohoes American*. They were dating before the golden wedding anniversary of Olivier and Angeline Boulerice Robert, you must remember them.

Did I ever take you to the island to see the replica of Henry Hudson's ship, the *Halfmoon*? It was built for the Hudson-Fulton Celebration many years ago, and in the twenties, a mayor had it placed on Van Schaick Island for public viewing. With this Depression, maintenance and protection has been reduced and the ship is falling into rack and ruin.

Have you seen the new comic strip by cartoonist Al Capp? His "Li'l Abner" is so entertaining. Speaking of which, have you heard the new NBC radio program featuring Popeye, Olive Oyl, Brutus, Wimpy, and Swee'pea. The tune "I'm Popeye the sailor man . . . toot! toot!" is echoing in my head and I cannot stand it. What happened to those endearing days of vaudeville when you graced the stage? Oh, how I long to see you perform again. But that is simply because, I am . . .

Your loving sister, Helen

(P.S. Under separate cover I will send the G&G potato chips you love so much, and yes, they are still made here in Cohoes.)

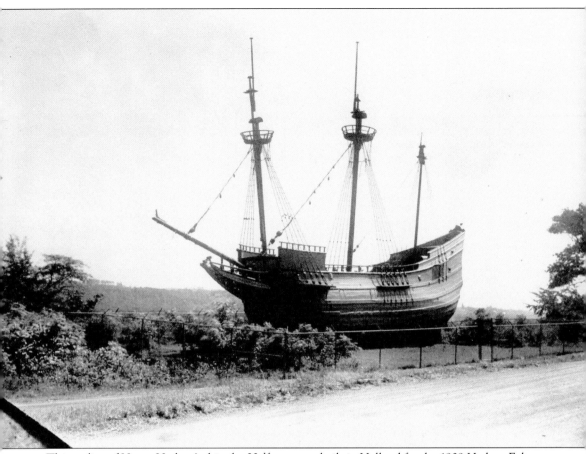

This replica of Henry Hudson's ship the *Halfmoon* was built in Holland for the 1909 Hudson-Fulton Celebration. In 1924, Mayor Cosgro had the replica brought from the Peekskill area to Cohoes and placed on Van Schaick Island. During the depression years of the 1930s, maintenance and protection was reduced and the ship was destroyed in a fire by vandals. Legend has it that the arson was committed by political opponents of Mayor Cosgro.

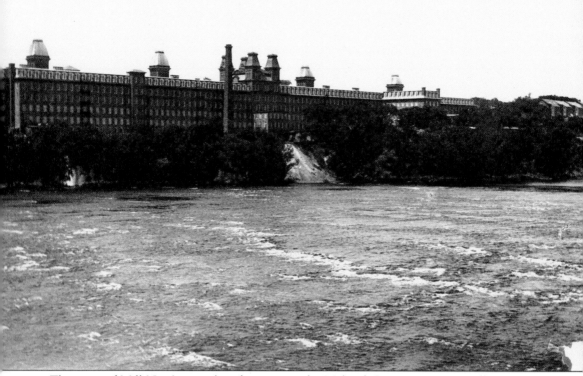

This view of Mill No. 3 was taken from across the Mohawk River. Harmony Mill No. 3 was designed by Cohoes architect and civil engineer David H. Van Auken, who was also the engineer for the Cohoes Company. In erecting the massive structure, two million feet of lumber were used, including 800,000 feet of hemlock planks and 500,000 feet of pine timber. The building required one million yards of stone, three million bricks, one million pounds of cast and wrought iron, and one thousand kegs of nails. The northern section was built in 1866–1868, with the central tower and southern sections completed in 1871–1872. The first machinery was run in the factory on January 1, 1868.

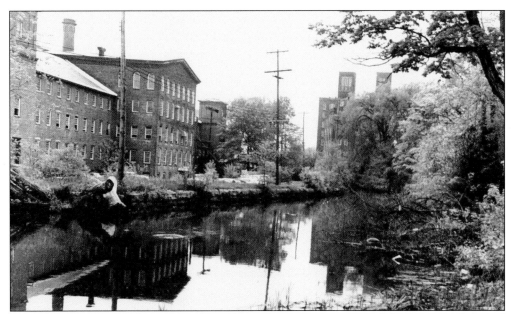

After the Erie Canal enlargement, the Cohoes Company incorporated this section of original canal into their power canal system. The Harmony Company later purchased the Ogden Mills and connected them together with the towering central portion. The mill is currently an apartment complex. The basement of the Carrybag building held offices and the *Cohoes American* newspaper print shop. The bags manufactured by Cohoes Carrybag were world renowned.

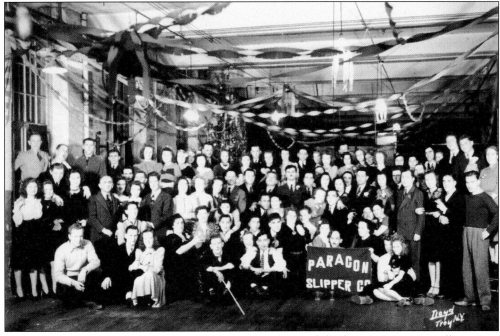

By the early 1940s, Industrial Properties Incorporated owned the former Harmony Mill No. 3 on North Mohawk Street. From 1941 to 1943 when the Paragon Slipper Company was housed in that building, eight other businesses leased spaces there as well. Julius J. Goldenberg of Troy was president of this factory, whose staff is seen here enjoying a holiday celebration.

The power canal, with a view of Mill No. 3 (left) and Mill No. 1 (right), is seen here. Harmony Mill No. 3, constructed in 1866, was frequently visited by cotton goods manufacturers from around the world. An addition it was built in 1872, making it the country's largest complete cotton mill. During the mill excavation in 1866, the contractors discovered the 11,000-year-old bones of a mastodont. The southern section of this mill houses two of the original Boyden turbines that powered it.

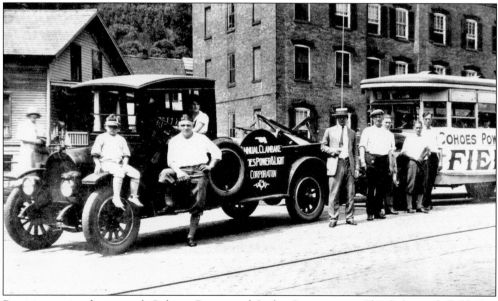

Participants in the annual Cohoes Power and Light Corporation Clambake and Field Day gathered on North Mohawk Street. Fountain Place is in the background. The Cohoes Company and Cohoes Gas Lighting Company became Cohoes Power and Light in 1919.

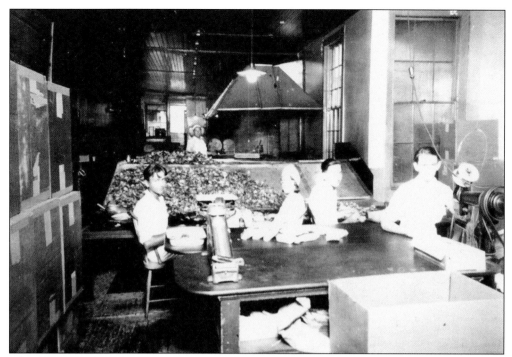

This is a view of inside G&G Potato Chip factory at 92 Oneida Street in 1928. Stephen Kosko, age 13, is on the left packing potato chips. The Potato Chip Manufacturing Company, begun in 1925, was later named G&G Potato Chip Company for owners Alexander Grega and John Guba. By 1931, the business moved to 91 Saratoga Street where it remained until 1951. The Saratoga Street building was later a club for the Orthodox Christian Association.

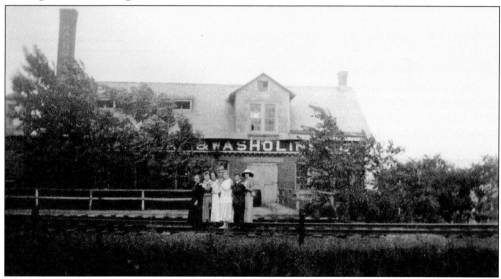

The American Washoline and Soap Company of 140–180 Central Avenue (by the New York Central Railroad) manufactured soap for textile factories. It closed its business in the late 1950s. On 1880s American Soap Company advertising cards, Washoline was called "the great dirt killer," and the product was "Awarded first premiums over all competitors at Rensselaer and Saratoga County Fairs, 1883."

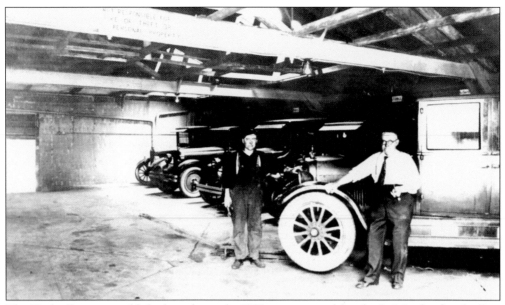

The Eagle Garage, established in the early 1920s, was owned by the LaMarche family. Part of the garage, located at 30–32 Congress Street, was rented to someone who did auto repairs. Grandfather Pierre LaMarche is on the right in the photograph.

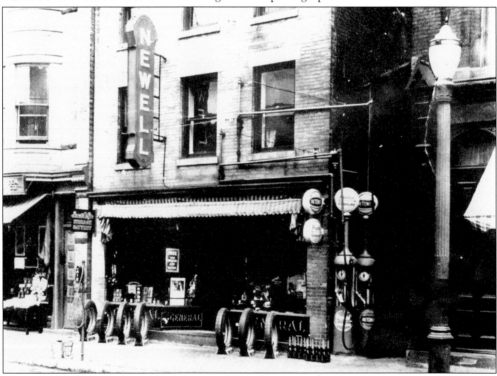

This is Newell auto parts and tire store. Elias Newell opened a Tire and Electric Store at 169 Remsen Street in the late 1920s. He advertised "Electrical Supplies and Contractors," "Tire Tubes and Batteries," and "Radio." He had an auto parts shop prior to this at 335 Saratoga Street, and in the early 1920s was a junk dealer.

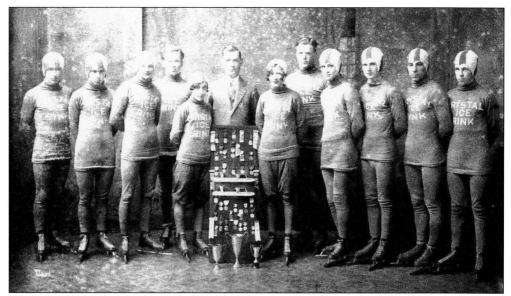

A Group of skaters from Crystal Ice Rink are shown with trophies in 1924. The skater second from left is Alex Sheremeta. Home base for Cohoes speed skaters was Carlson's Ice Rink, run by Iver Carlson for 44 years starting in 1910, when he purchased the Cohoes Ice Rink. The Cohoes Ice Rink was originally established on Ship Street in 1892 by Thomas Wallace, who also owned the *Cohoes Republican*, an early Cohoes newspaper.

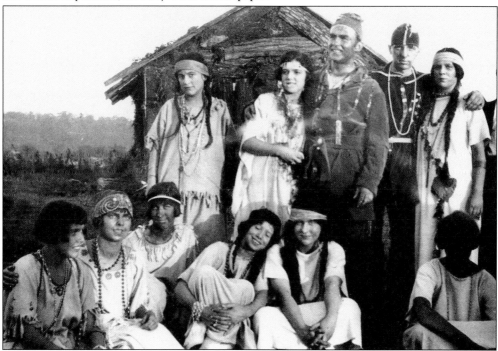

Amateur photographer Charles Neeson, who lived on Van Schaick Island, took this photograph in the 1920s. It was one of the many pageants held at East Side Park by the Van Schaick Pond. This may have been a re-creation of Henry Hudson's 1609 exploratory journey up the Hudson River.

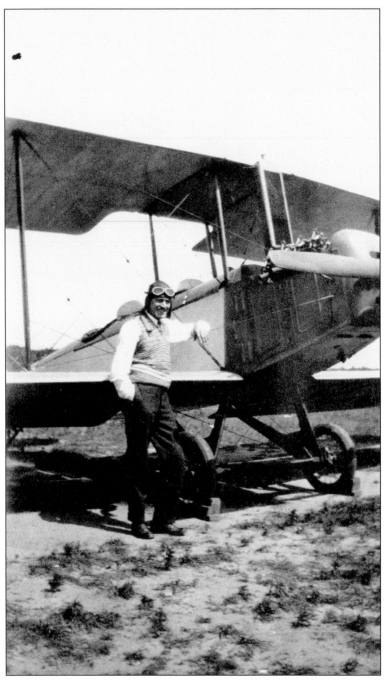

Ray Stocker Jr. is seen here with a Jenny Commandaire airplane at the Cohoes Airport. The Cohoes Airport was built around 1926 on the Murphy Farm property, located west of Baker Avenue (now in the town of Colonie). The airport was opened by Gilbert Robert, and began with a single biplane piloted by Tex Perrin. The plane hangar was built by Alex Garceau, who received a plot of land on the Murphy Farm in compensation for his labor. The airport only survived two years. During that period, air travel was still viewed as a novelty rather than a form of routine transportation.

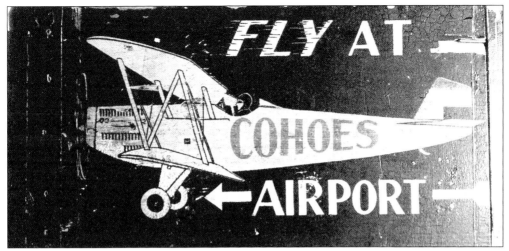

During its short existence, the Cohoes Airport hosted experimental aircraft and daring aviators. An experimental biplane was built at the airport, which crashed on its initial flight on the neighboring Phoenix Farm. The airport was closed following another plane crash, this time of a biplane piloted by Tex Perrin. While performing a stunt during an air show in which he attempted to burst balloons with the plane's propellers, Tex flew too close to the ground and crashed. Although he survived the crash, this ended the airport's existence. Few remnants of the airport exist at the site today. However, the Spindle City Historic Society has been given one of the airport's signs (above), which is on display in the Cohoes Visitor's Center.

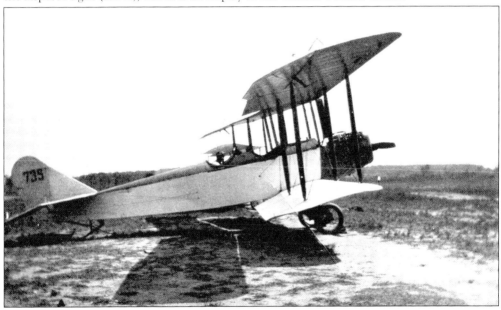

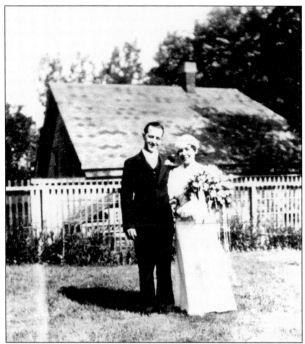

This wedding picture of Armand and Rose (Turcotte) Bernard on June 3, 1933, was taken in the backyard at 70 First Street on Van Schaick Island. Armand was a shipper, and the couple resided on Erie Street in the north end of the city. The house on First Street where this photograph was taken was owned by Rose's parents: Lena, a clerk, and Sinai (Hortense) Turcotte, a machinist.

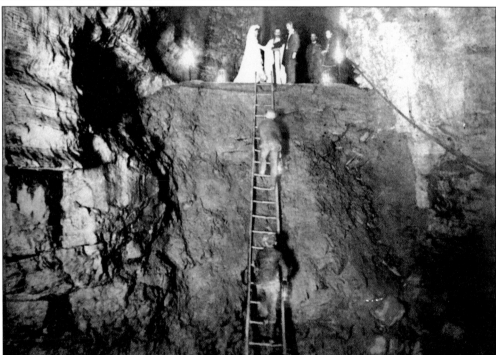

Unusual wedding destinations are not a new idea. This wedding of a Cohoes couple took place in one of the region's caverns, Howe Caverns near Duanesburg. Cohoes has its own share of subterranean spaces, with a network of power canals under the streets that once served the city's many mills. Some of the tunnels are up to 60 feet underground, and a few so large they can accommodate trucks.

The Cohoes Falls have always been a destination for tourists and locals alike. In dry weather, the water over the falls becomes a trickle, and it becomes possible to walk across the rocks and climb the shale slopes where the water usually flows. Here, Armand Bernard poses in 1930, sitting in the falls themselves, near the distinctive "nose" of the falls where the rocks jut out.

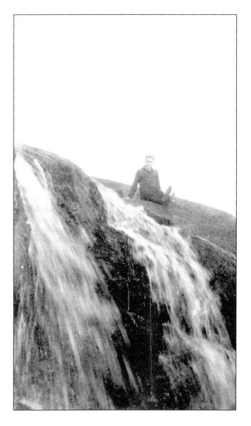

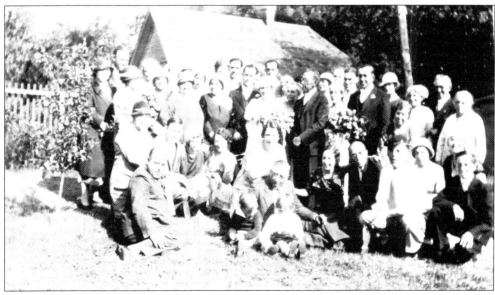

This is the 1933 wedding reception of Armand and Rose Turcotte Bernard in the family's backyard. Receptions of the day did not include guests other than family members, so it is unusual to note the size of this reception. Only the wealthy families of the day would have had a catered reception.

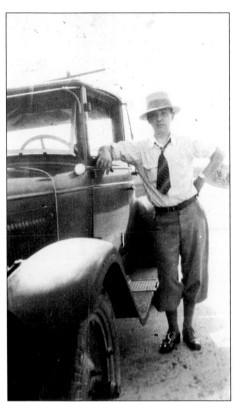

Times have changed, but a man's pride in his car has not. Note the tilting windshield for ventilation, the running boards, and the small parking light on this commercial vehicle. John Ryan's tie length was fashionable in 1928, with the plus-fours (wider in the leg than knickers) and his straw hat. His opened collar indicates casualness, suggesting that the photographer was male.

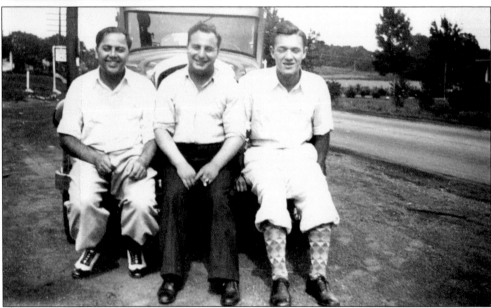

Al Desmarais (left) and John Donlon (right) pose on a car with an unidentified companion in this early-1930s photograph. Donlon was owner of the Donlon Insurance Agency. The Donlons were insurance counselors in Cohoes from 1899 until the business moved to Troy in 1970. Notice the dapper spectator shoes sported by Desmarais and the snazzy socks and knickers worn by Donlon.

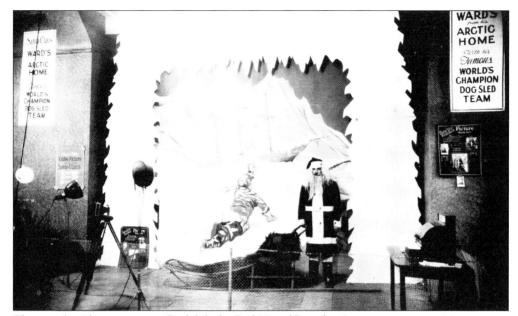

The popular Christmas song "Rudolph the Red-Nosed Reindeer" traces its origin to Montgomery Ward. The song was based on a poem written in 1939 given out by Santa in the Chicago Montgomery Ward store. About 2.4 million copies of the illustrated booklet were distributed that season. The song was recorded by Gene Autry and became his all-time best seller. Next to "White Christmas," it is the most popular song of all time.

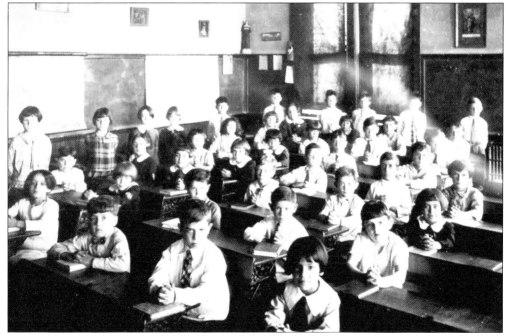

Sacred Heart, on Van Schaick Island, was a French parish. Like St. Joseph, the parish built a school to assure the survival of the French language and culture. The first classes were held in the wooden chapel once the present church was built in 1889; a brick school was later constructed. This c. 1930 photograph is of the third and fourth grades.

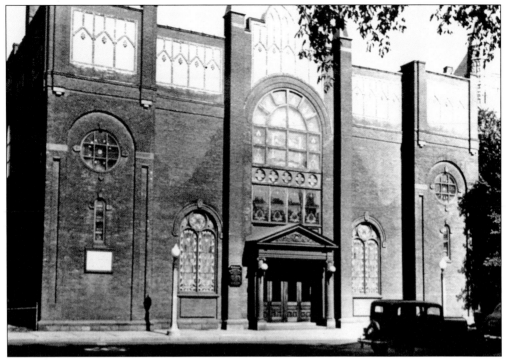

The First Baptist Church was established in 1839 and the first meeting house was built in 1840 at the corner of Remsen and Factory (Cayuga) Streets. In 1850, the church moved to its permanent site on the southern end of Mohawk Street. The church was rebuilt in 1922–1923, removing a center dome, appearing as it does in this 1936 photograph and to this day.

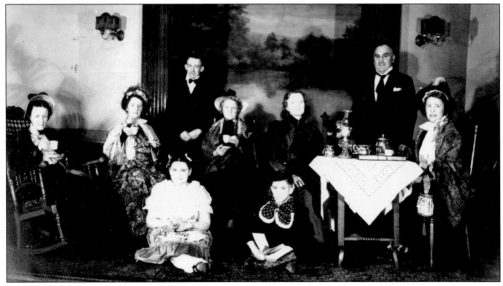

Posed here is an intergenerational group of members of the congregation of the First Baptist Church who are celebrating its centennial on Mohawk Street in 1939. They are participants in a pageant depicting various periods of the history of the church. At the time of this anniversary, the Rev. George F. McElvein was pastor, Warner M. Howell was the superintendent, and Carrie Quackenbush was the sexton.

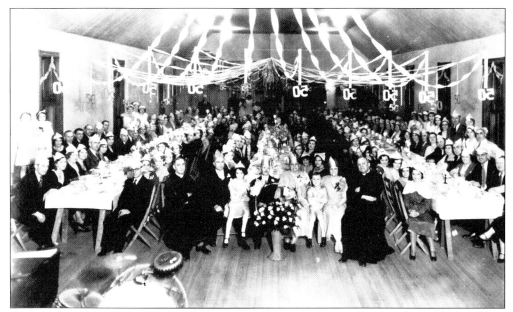

Gathered at the old St. Marie's Hall in 1932, this group is celebrating the golden wedding anniversary of Olivier and Angeline Boulerice Robert. Notice the drum set in the foreground, you can bet this group was going to be swinging before the night was out.

This 1931 photograph is from the 25th anniversary celebration of the founding of St. Marie's Parish. The church was incorporated in 1906 to serve Catholic families in the "hill" section of the city, primarily mill workers of French Canadian origin. The celebration included the comedic play "Les Bohemiennes," performed in French. Ernestine Marion (fifth from the right, standing) was the kindergarten teacher at St. Marie's School for more than 50 years.

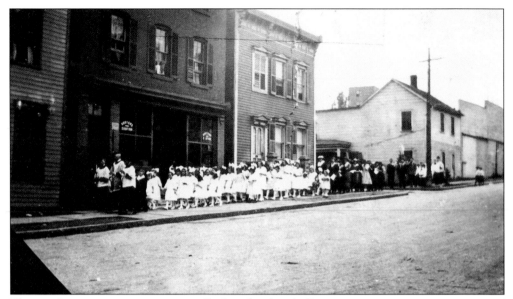

This is a first communion group near St. Josephs church. Processions were an important part of elementary parochial education of the day. A group of young girls is led down the street by the priest and two altar boys. The group, about to receive their first communion, is dressed alike, with shoes, stockings, dresses, and bows in their hair, all in white.

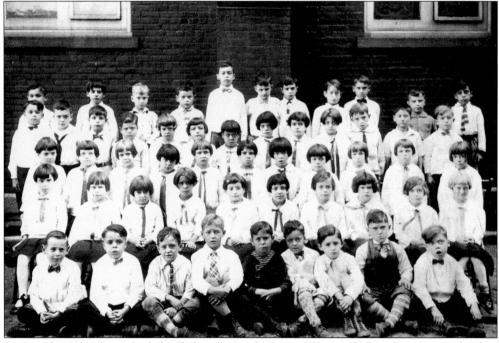

St. Joseph's School was built by Father (later Monsignor) Dugas. When he instructed a first communion class, he was appalled to find out that the children were losing knowledge of the French language. He built a parochial school staffed by a French Canadian order of nuns, the Sisters of Ste. Anne. The Sisters used both French and English as the instructional languages. Here, we see a class from the year 1930.

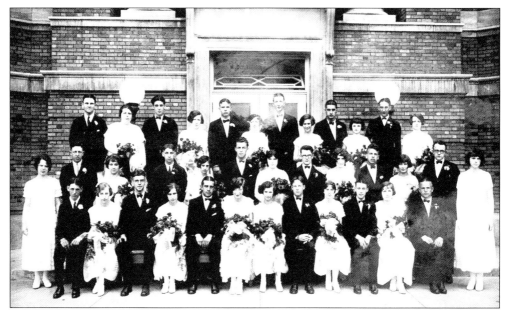

Here is the graduating class of Cohoes High School around 1920. Jessie Carpenter, who later became owner of Carpenter Florist, is in this class, as is Raymond Knorowski, who became a teller at the National Bank of Cohoes and owned 154 Park Avenue, which was once used as the rectory of the Sacred Heart Church. Carpenter was valedictorian of her class, as were her mother and grandmother.

This photograph was taken in Niagara Falls in 1928 at the State Convention of the United Spanish War Veterans Ladies Auxiliary. The first on the left is Mary Agnes Collin, department president in 1937. The Ladies Auxiliary No. 53 met at the Odd Fellows hall on Mohawk Street, just north of city hall.

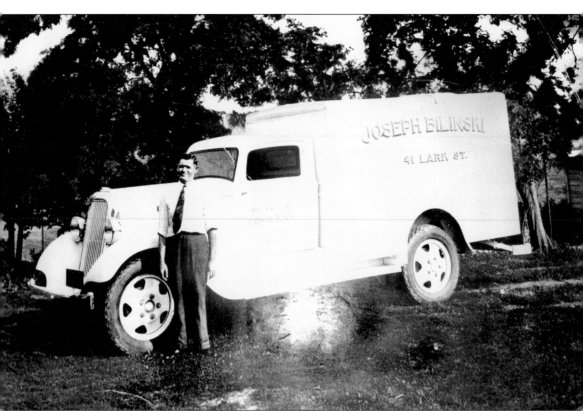

In the early 1900s, Joseph Bilinski emigrated from the Ukraine and established a farm on Wade Road in Colonie, where he began to make kielbasa. The family moved to Cohoes around 1924 and established their business in their home on a 10-acre plot at 41 Lark Street. A smokehouse was purchased for $5 and kielbasa was made in the kitchen for several years. By 1931, a sausage kitchen was added to the smokehouse and the product line expanded to include frankfurters and bologna. Products were sold at 41 Lark Street but deliveries were also made, beginning in the late 1930s, to other local markets.

This man is evaluating brew for clarity at Penrose and McEniry Brewery. It was advertised that "Penrose and McEniry's Ale has a high and well-deserved reputation for its purity and wholesome qualities. . . . A drink of this Ale to a tired person is as refreshing and more strengthening than a drink of cold water in an oasis to a desert traveler."

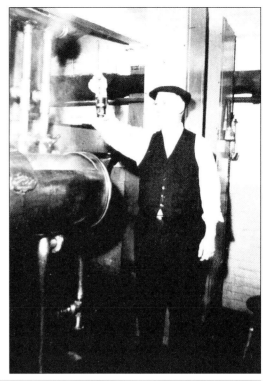

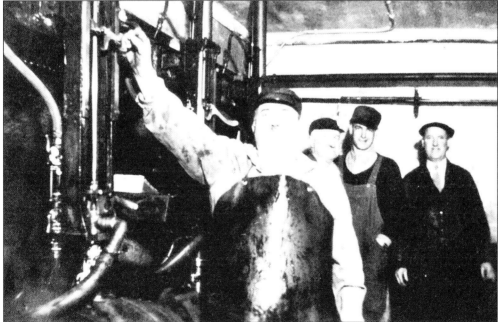

Here are workers inside of Penrose and McEniry Brewery. The brewery closed during Prohibition, and the building was later damaged by a 1931 fire. While fighting the fire, firemen narrowly escaped injury when the trademark beer keg fell from its mounting on a flagpole on top of the building. The sturdy walls and foundation of the brewery building that remained were used in the construction of the second St. Rita's church.

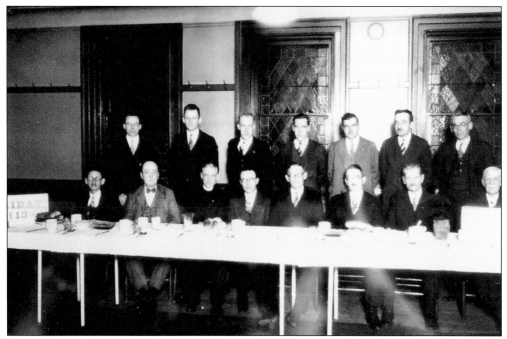

Seen here is the Cohoes Masonic Order's Friday the 13th Club meeting in the 1920s. The Cohoes Lodge was organized in 1846. The date, Friday, October 13, is significant to the history of the Masons. On that date in 1307, the Order of Knights Templar was arrested and some were put to death by the French king. This is connected with Friday the 13th being a day of bad luck.

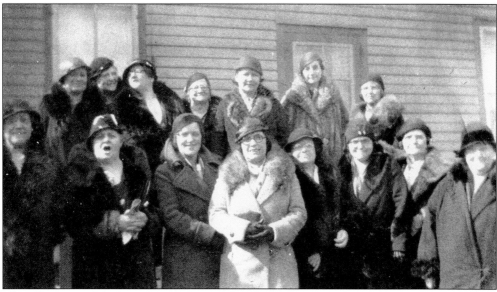

The Idle Hour Club meets here in 1933. The short woman in the middle of the second row is Delia Fontaine. She lived at 164 Vliet Street with her husband, David, a carpenter. In the second row, second from right, is her daughter-in-law Eveline Fontaine. David Jr., Delia's son, and Eveline resided at 48 Watervliet Avenue. In the second row, last on the right, is Eva Carmody. Norms of the day demanded wearing gloves and a hat for any outing.

Dr. Joseph Amyot, a Cohoes dentist, trained his seven boys and three girls in gymnastics. This 1930s photograph was taken behind the family's residence at 194 Central Avenue. In the background, notice the American Washoline Company, where soaps and washing products were made until the late 1950s.

This summer 1939 photograph was of the Polish National Alliance Drum and Bugle Corps posed on Mohawk Street in front of the Cohoes Post Office. The group was formed in 1937. Wanda Slupski was the first drum majorette, and Frances Guzek was later majorette for the group. The corps appeared in parades and in competitions. They received several awards as the best dressed drum and bugle corps in the state.

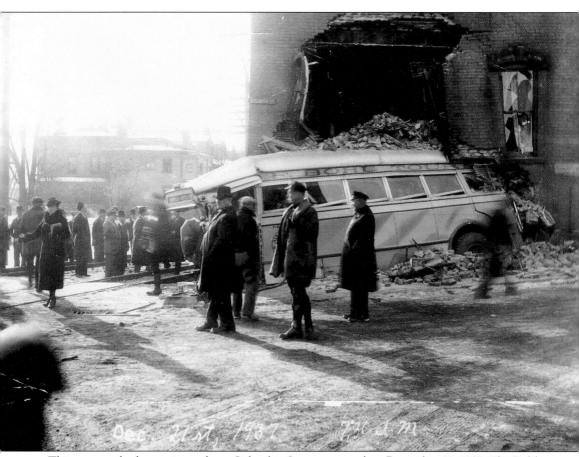

This spectacular bus-train crash on Columbia Street occurred on December 21, 1937. The Bohl Brothers bus skidded near the base of the hill, was struck by a D&H passenger train, and then was thrown into a four-story brick house at 6 Columbia Street. Amazingly, bus driver Francis Wise escaped serious injury. There were no passengers on the bus, which embedded itself in the building. Wise climbed out of the side of the bus once the falling bricks and plaster had settled. Members of the four families occupying the building were unharmed by the crash, including a baby sleeping in a front room on the second story whose crib was surrounded by debris from the wreck.

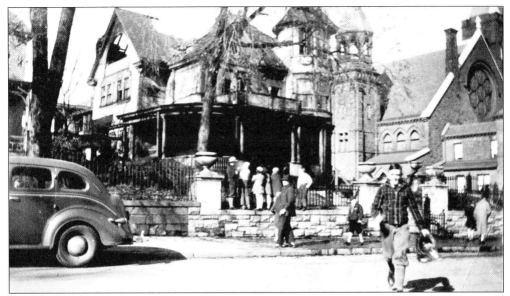

On October 24, 1939, police and firemen rescued 12 nuns when fire destroyed the St. Bernard's Convent at 100 Mohawk Street. Sister Celine risked her life to run back into the chapel and rescue the sacramental hosts. The structure in the right of the photograph is the Silliman church. An HSBC Bank is currently located where the convent once stood.

Seen here is Central Avenue, before the street was paved, in the 1920s. The building at the right was a brewery at the present site of St. Rita's Rectory, at Lansing and Newark Streets. The brewery operated at this site under different owners. Over time it was called McEniry and Rosskam, McEniry, and Penrose and McEniry. The house on the left is 51 Central Avenue. The Tremblays have lived there since 1914.

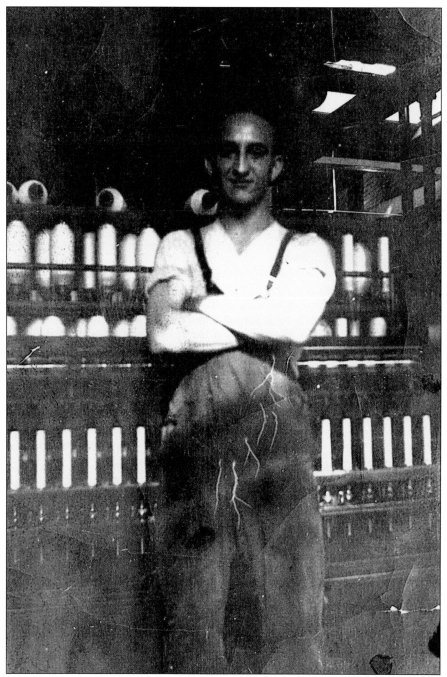

Leo Girard worked in the Harmony Mills as a doffer. Doffing is the winding of thread onto large spools used for sewing. The position of doffer was considered one of the more prestigious occupations for mill workers. Girard's supervisor told him that if he learned how to doff he could get a position as a doffer. Every day when he finished his work as a mill hand, he went to the doffing room on the fourth floor of the mill to assist the doffers, and began to learn the job. When the boss in the doffing room realized that Leo was a trained doffer, he was promoted to the job. Leo's mother, Lena, and father, Tancred, also worked in the Harmony Mills.

The Beaunit factory, in the Harmony Mill No. 2 building, was in business from 1934 to 1953. Beaunit primarily made baby clothes.

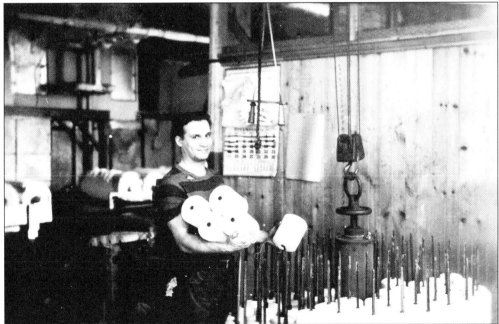

John Vega is at work at the Beaunit Mill in the mid-1930s. Vega worked at the mill as a dyer. He was also a musician, playing guitar and banjo, performing from the 1940s through the 1960s with the Paul Trio. Vega was also part of a banjo group with bandleader John Walsh. He gave music lessons on guitar and banjo at Romeo's Music Store on Remsen Street during the 1940s and 1950s.

The baby in the wicker carriage is the daughter of Rose Loiselle La Riviere. If the New York Society for the Prevention of Cruelty to Children, which was founded in 1875, had witnessed this child left alone in front of the billiard parlor, there would have been an immediate investigation. The first anti-cruelty laws were enacted on behalf of animals; only later were laws instituted to protect children.

This is a LaMarche family photograph. From left to right, they are (first row) Alfred Jr. and his sister Alice Frances; (second row) Alfred LaMarche Sr. and his father Pierre.

Five

1941

My dearest Addie,

I cannot believe I will be packing up and moving down to be nearer to you in Flushing this coming fall. Always the organizer, I have already begun to sort through the family's keepsakes. I have made contact with the local historic society and they are very interested in anything I have of Cohoes's history. Remember, Father's side of the family goes back before 1872 in Cohoes and Mother's, before 1875. Grandfather Dickey was a contractor and Grandfather Abel was a cigar maker. In those days I think the men had it easier then the women. They only had one job!

I have already saved some of the early photographs of you. My, you looked magnificent! But how those newspapers referred to your stature: a toy danseuse; so petite she has no surname; a stocky, heavy limbed midget, but full of elasticity as a rubber ball; half-portion as to size; her figure has developed gracefully and symmetrically, though she is not tall enough to converse with on ordinary sized person without standing on the points of her toes and throwing back her head to gaze upward; and lastly, a four-foot five-inch dancer who went on to become a ballet specialist. My favorite review of yours was the one that stated that one of your specialties was a contortion-like backward kick which made your left toe whisper into your right ear. Oh, if those feet of yours could talk, what tales they would have to share. I digress. Let me fill you in on our hometown.

So much has changed. All anyone discusses anymore is the war in Europe. All you read about is Nazi, sabotage, London being bombed. I hope it ends soon without involving us. It is already affecting our boys here in Cohoes. Members of Cohoes's ninth contingent of draftees left recently for the Albany induction center and final exams. My best is with them.

I went to the Lyceum last night. There were 140 tables in play for a mammoth card party held by the St. Agnes Church. I did not even win a door prize, let alone a game. The other night a group of us took in *The Strawberry Blond* with Jimmy Cagney, Olivia de Havilland, and Rita Hayworth. It was wonderful. His next film is *Yankee Doodle Dandy* where he will play George M. Cohan. Weren't you on the same bill with Cohan in vaudeville? We have the Rialto and Regent Theaters now to see these movie spectacles. Between the movie, newsreels and Bingo, it makes for a full evening of entertainment. They are also opening another theater in August. It should seat 1,100 people. Can you believe that? In our little hometown of Cohoes. I wonder what they will name it.

Speaking of vaudeville, can you believe they are calling the act of Gypsy Rose Lee "family entertainment" like the vaudeville days? I remember how you always had to be careful about your bookings—vaudevillians on a burlesque stage, never! Gypsy Rose Lee should just stay in Chicago where she is playing now.

I am enclosing a picture of the annual dinner party of the Cohoes dancing class that was in the *Cohoes American* recently. Do you recognize some of the names? Some are the children and even grandchildren of our friends and neighbors. The parents of George Coonrod now own our old house on Imperial Avenue (he's fourth from left in the back row). Obviously, the house must be visited by the muse of the dance. Speaking of dancing and routines, I saw the Boy Rangers Drum and Bugle Corp. perform in front of the post office a few weeks ago. The one girl in the group entertained wonderfully.

There is a special event at Beaunit Mills and the owner, Mr. Beasley, invited me to the event while at the social the other night. The only other person attending that I know is Mrs. Amyot. Sounds like it may be political, so I don't know if I am interested in going. Besides, I would have to get a new dress and I cannot find a style that is right for me anymore. Maybe I should check Juliette's again. I might go to the Cohoes High School fashion show in a few weeks to check out the latest trends.

Anna Krutka sent over a loaf of bread again. She knows that I cannot bake to save my life. I always follow a recipe, but it never comes out right. Anna says you have to do it by feel. I just remembered, she works over at Beaunit. Maybe she can tell me what this upcoming event is about and if it is worth attending.

Your loving sister, Helen

This wartime photograph of Eva Ploude Amyot (1886–1946) shows her wearing a pin indicating that six of her 10 children were serving in the armed services. She was a member of the Albany County Board of Supervisors and the wife of Cohoes dentist Joseph G. Amyot.

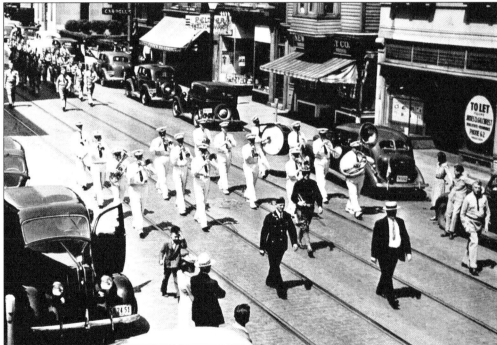

This was Remsen Street on Memorial Day in 1941. Note Carroll's Shoe Store, Pellerin's Drug Store, Timpane's Jewelers, and the Methodist church, all of which made for a vital "main street" during Cohoes's heyday as a thriving small city. Lackmann's Sporting Goods was across the street and remained in the Lackmann family until later that year. The tradition of a Memorial Day parade in Cohoes continues to this day.

Seen here is the gas station dog, Bobby, at the gas station on Vliet where Bazar's is now located. In those days, a stop at the gas station meant full service. An attendant always pumped the gas and checked the oil and tire pressure routinely, as a courtesy to the customers.

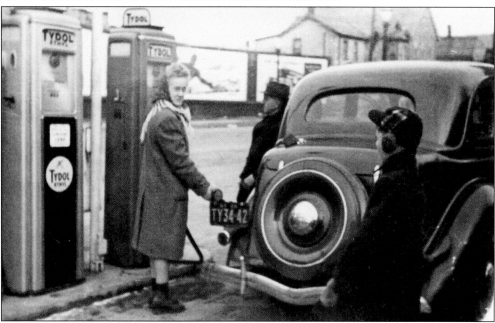

This photograph was taken in the 1940s at the corner of Ontario and River Streets, by the branch of the Mohawk River near the Reavy Bridge. The station was owned by Charles Gendron. It was a full service station that pumped gas and offered complete repairs. It was unusual in those days to see a woman pumping gas.

This photograph of Howard J. Brennan and an unidentified coworker, salesmen for Hathaway Bakery, was taken on a morning in 1946. Hathaway Bakery was located at 59 Olmstead Street The bakery opened in 1943 and remained in business until 1952. Howard was later a salesman for the Educator Biscuit Company in Albany, and began working at the Watervliet Arsenal in 1963.

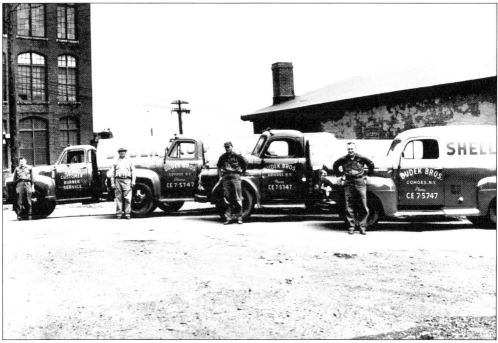

Dudek Brothers trucks and drivers stand at their place of business on Champlain and Oneida Streets (near where the end of route 787 is today) in this early-1950s photograph. The former Fuld and Hatch Mill is in the background. The Dudeks were distributors of fuel oil and wood. Some family members delivered milk and other dairy products.

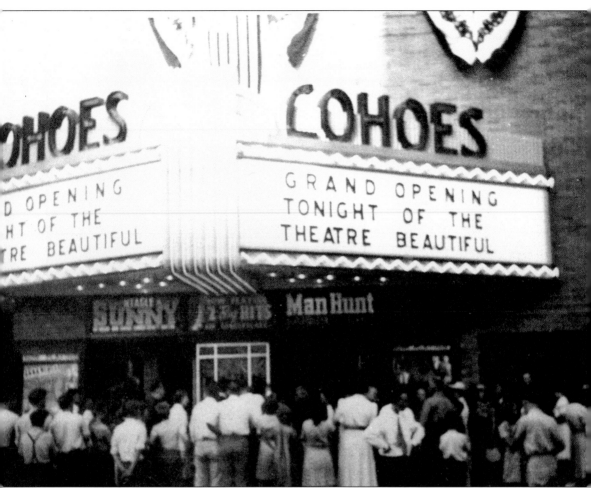

The theater, part of the Fabian chain of theaters, opened on Tuesday, August 5, 1941. The featured films that evening were *Sunny* starring Anna Neagle, and *Man Hunt* with Walter Pidgeon and Joan Bennett. The theater, which seated 1,100 people, included tapestry brick and black granite in its construction and was equipped with the latest Century Projectors and an RCA Fantosound system. The interior was in a modernistic style, with brown, red, silver, and blue in its color scheme, and was air-conditioned, a feature widely promoted in those days when it was still a rarity. The theater advertised "Always 2 Big Features" and there was a complete change of program on both Wednesdays and Saturdays.

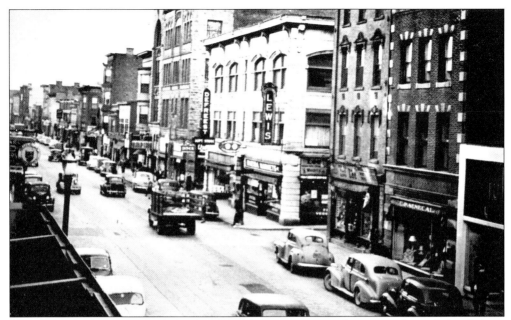

In this Remsen Street scene in the 1940s, the Masonic temple is on right and the Cohoes Opera House is to the left of the Masonic temple. The stores on a busy Remsen Street include National Auto, the Lewis Department Store, Defreest's, Juliette's, the Army and Navy store, and Timpane's Jewelers.

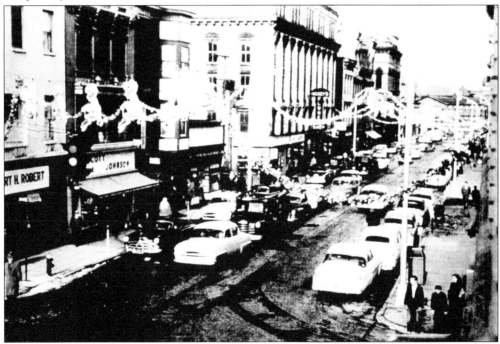

This picture of Remsen Street, north of Ontario, is decorated for Christmas 1953. The photograph was taken by Fran Hanlon. Among the businesses at the time in this section of Remsen Street were the Sanitary Fish Market and Western Auto Supply. This was a time when downtown was the place to shop, and Remsen Street was the heart of the city's downtown shopping district.

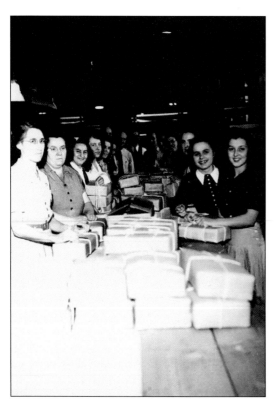

This is the shipping area at Beaunit Mills in Mill No. 2 at the Harmony Mills complex. The group of people around the table are preparing manufactured cotton items to ship in this 1940s photograph.

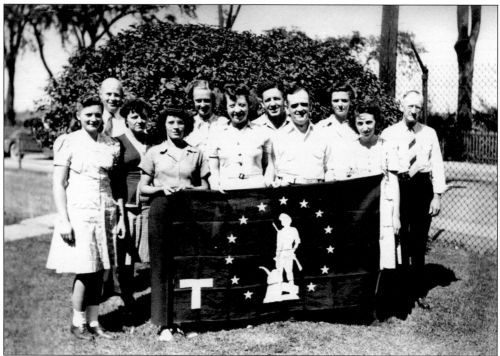

People are on Beaunit Mills grounds with Minuteman flag in the 1940s. On the far right is Mr. Beasley, owner of the company.

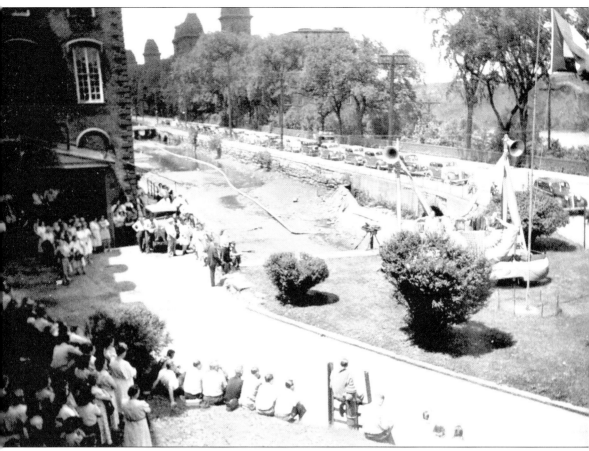

Seen here is a 1940s special event on Beaunit Mills grounds, in front of Harmony Mill building No. 2. The former power canal for the mill (then empty of water) can be seen in the image. This power canal is now Power Canal Park with interpretive signs that describe the Harmony Mills Historic District. Note the bunting and flags on the reviewing stand.

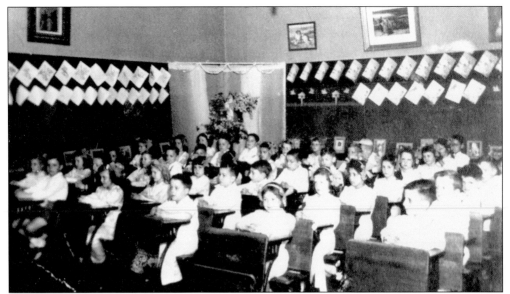

Nuns staffed the St. Agnes School, like all other parochial schools. Here is Sr. Mary Theophane's fourth-grade class on May 31, 1946. The parish complex included the church, the school, a rectory and convent, and the Lyceum, which contained a gymnasium, stage, and a bowling alley in the basement. The parish, founded in 1878, was merged with two other city parishes in 1996 by the Albany Diocese.

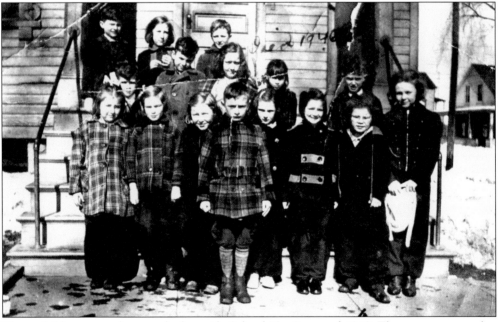

These children were photographed outside School No. 9 around 1940. The two-story wooden building was constructed on Lincoln Avenue in 1875. It is now the Cohoes Rod and Gun Club From left to right are (first row) Jean Beaupre, Doris Hines, Martha Le Grand, Joe Brooks, Mildred Laughlin, Joan Mosher, Kay LaPorte, and Gloria Hebert; (second row) Jackie Parker, Fred Laughlin, Vivian McDermott, Grace Valoze, and Buckey Hebert; (third row) Vincent Weglarz, Mary LeGrand, and Stash Mnich.

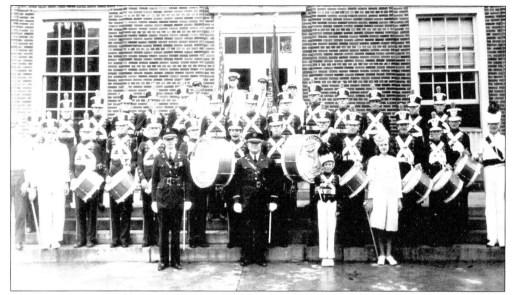

This late-1930s or early-1940s photograph shows members of the Boy Rangers Drum and Bugle Corps of Cohoes. This band was the junior corps of the E. T. Ruane American Legion Post. They performed in numerous events in the area. Many members of this band went on to join the Empire State Grenadiers. The one girl in the group is Monica Aymot.

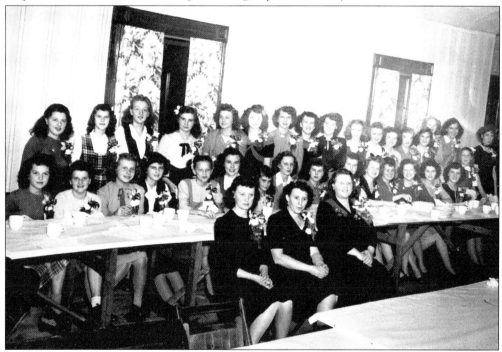

This Polish National Alliance (PNA) banquet included all members of the PNA Girls Drum and Bugle Corps at the time, around 1945. In the front row are Helen Darwak, Lena Kowalik, and Bertha Rusiecki. In 1944, the corps became affiliated with the Mohawk Valley Junior Drum and Bugle Corps Association. They appeared in contests sponsored by this organization, as well as participated in parades and processions at St. Michael's church.

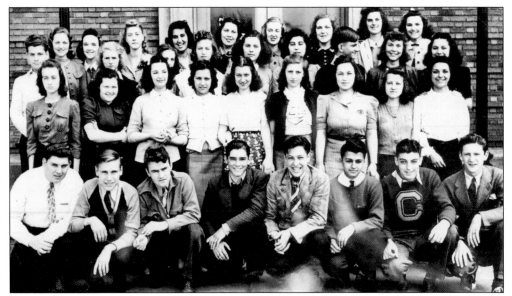

Seen here is the Cohoes High School Junior Prom Committee of May 24, 1940. From left to right the students, identified by their last names, are (first row) Lanoue, Mazur, Halloran, Lis, Bisnett, Marra, LaBarre, and Callaghan; (second row) Nolin, Mulcahy, Casey, Soulier, La Point, Murphy, Blais, Zarzycki, and Zandri; (third row) Quevillon, Keeler, unknown, Belleau, Santspree, DerBedrosian, Nicolson, Manning, and Breslin; (fourth row) Marcil, Ashley, Bottum, Abdella, Evertsen, Twiss, Moran, DeMio, and Cummingham.

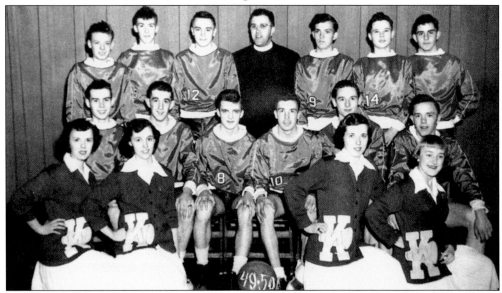

The 1949–1950 Keveny Memorial Academy varsity basketball team and cheerleaders pose in this photograph. Cheerleaders in the first row from left to right are Betty Ann Chouiniere (1950), Betty Cannon (1950), Pat Dufresne (1950), and Barbara Carr (1950). The basketball players from left to right are (second row) Don Dwyer (1951), Ray Noel (1951), Bill Sorensen (1950), captain Bob Daigneault (1950), Jack Lanthier (1952), and Charley Chouiniere (1951); (third row) Jim McDonald (1952), Ernie Jarvis (1953), Ernie Steele (1952), coach Rev. Donald Gravelle, Frank Gladu (1952), Roy O'Keefe (1952), and Jack Parker (1953).

In this early-1940s photograph, Cohoes
Merchants baseball player Ed Tremblay shakes
hands with teammate Ed Kalski. Kalski went
on to pitch with the Albany Senators in the
late 1940s. He later played with the Cincinnati
Reds farm system and in the Western Canada
Baseball League. Stiles Brothers Hardware store
was located at the corner of White and Remsen
Streets for 100 years until the late 1970s.

Patrons of Mom's Homemade Ice-Cream Parlor, located at 33 Remsen Street, are photographed
by Veronica Krutka. This store was owned and operated by Ida Miner in 1951. Ice cream was 20¢
a scoop, and there were just two flavors, vanilla and chocolate. The shop had large ice-cream
sundaes, but you had to eat quickly—you were only allowed to spend 20 minutes in a booth.

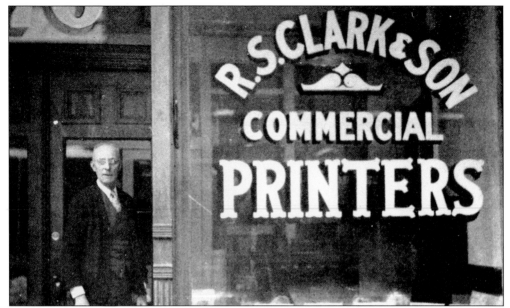

R. S. Clark and Son Printers was established in June 1889 at 24 Remsen Street. The business was later located on North's Block, 49–51 Mohawk Street. When the building was torn down in 1937, the business moved to 76 Mohawk Street, where it remained until 1950, when it moved to another location to accommodate the growth of the business.

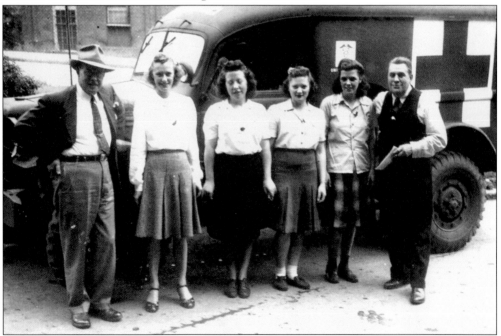

This photograph was taken in the 1940s. The Cohoes branch of the Red Cross was organized in April 1917. Cohoes Mayor James S. Calkins was honorary chair, and 5,000 members were secured in the first membership drive. One of the first major efforts of the Red Cross in the city was during the 1918 influenza epidemic. Many prominent Cohoesiers were involved over the years in Red Cross fund drives.

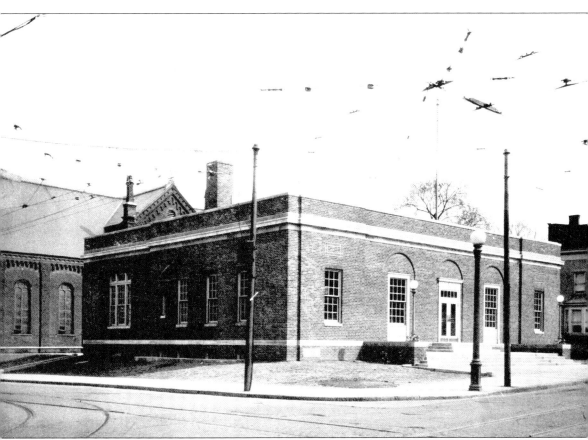

The Cohoes Post Office building at the corner of Ontario and Mohawk Streets was constructed in 1924. The first post office in Cohoes was established on February 23, 1832, located in postmaster Frederio Waterman's store near the junction of the Erie and Champlain Canals. It was the practice at that time to appoint local businessmen as postmaster and locate the post office at their place of business. The following year, Hezekiah Howe was appointed postmaster; the post office moved to his store on the canal bank near the Jute Mill. The mail was delivered by Cohoes resident Wright Mallery, who had a bakery in West Troy. He carried the Cohoes mail along the canal line in his bread cart.

Seen here is Anna Krutka (mother of Veronica) in 1941 making bread at home. She was the mother of the Cohoes police officer John Krutka. Many Polish immigrant women baked bread for their families using traditional recipes handed down through generations. Often these recipes were not written down but instead relied on the experienced eye and skill of the cook for their success.

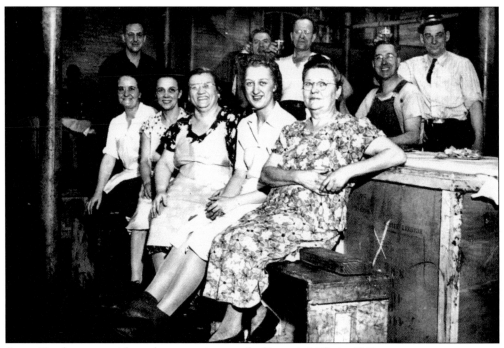

Anna Krutka poses with work companions at the Beaunit Mills in 1941.

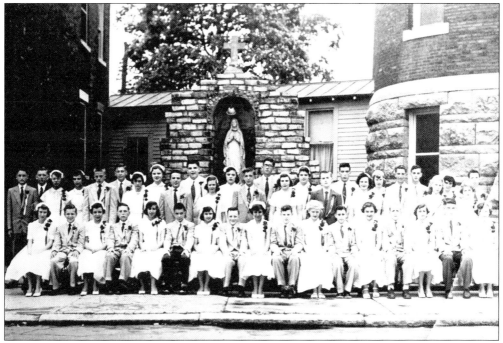

This 1953 photograph shows the eighth grade graduating class of St. Agnes School. The photograph was taken in front of the grotto which was situated on the corner of Garner and Johnston Avenues.

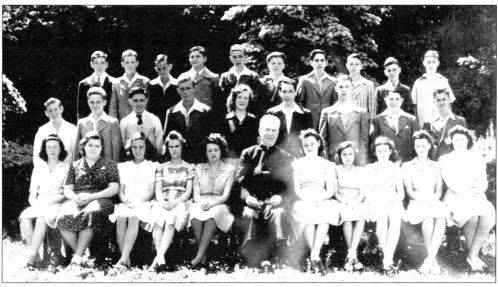

Seen here is the Keveny Memorial Academy eighth grade class of 1943. From left to right are (first row) Elaine Mahoney, Peg Dingman, Pat Russell, Theresa Robitaille, Sue Foley, Fr. William Brennan, Jackie Moquin, Peggie Heeley, Noreen Kenton, Eileen Corr, and Jean Brown; (second row) Robert Bowen, Tom Brown, Bernie Fitzgerald, Jack Tully, Beula Owens, Joe Corbeil, George Marble, Tom Cannon, and Bob O'Leary; (third row) Bill Clairmont, Bill Casey, Leo Petticult, Gerald Vandenburgh, Gerald Reed, Nash Vedald, Dr. Dick Cuddy, Leo Rigney, and John Reese.

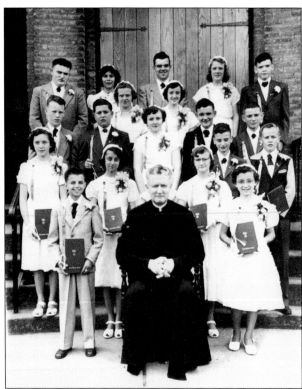

St. Patrick, in the Orchard section of Cohoes, was built to serve the needs of the Catholic population that lived in Harmony Mill housing in that section of the city. Here we see the St. Patrick graduating class of 1950. With them is Father Kavanaugh.

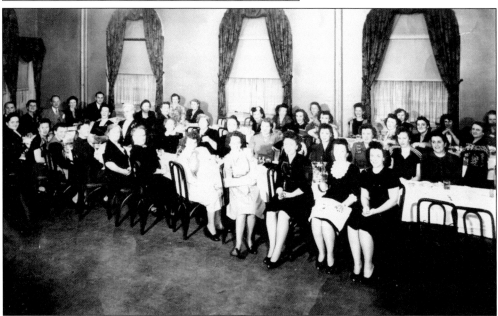

Gracette Manufacturing Company of Cohoes holds their c. 1944 Christmas party in the Elks Club of Cohoes. Those in attendance included: Louise Sylvester, Jo Kennedy, Stella Hoinski Simmons, Albina Plouffe, Marie Malow, Kay Landor, Helen Student Rynasko, Elizabeth Archambault, Malvina DesChamps, Helen Sapatek, Julia Benoit, Mary Olzwy, and Esther Forsythe.

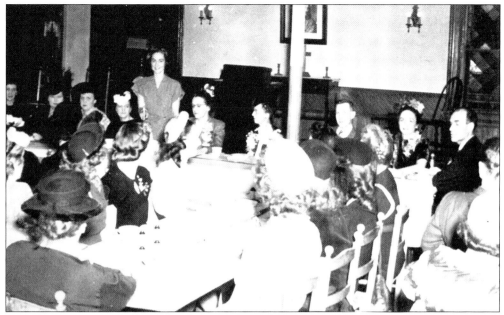

On February 18, 1947, Cohoes Public Schools celebrated the 50th anniversary of the National PTA. Mary Dotter, high school librarian, stands to the right of speaker Madelon Hickey, high school principal. A musical program was presented by the high school music teacher Maurice Starkey and his wife, seated at the end of the table. Others at the head table are Mr. and Mrs. McCreary, Mrs. Montplaisir, Mrs. Brehm, Mrs. Lindsay, and Byron Williams.

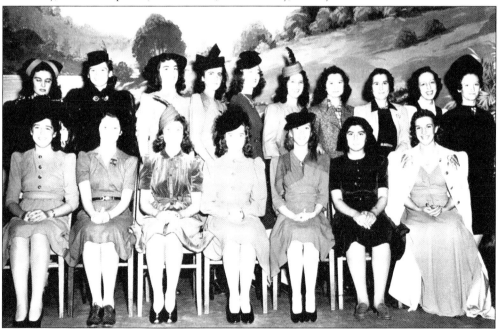

Among the many fund-raising activities undertaken by high school students of the 1940s were fashion shows. Parents and friends would attend to show their support for the students. Here, we see a Cohoes High School class wearing the latest fashions of 1941. The clothes were from the Juliette Shop and the hats from Harriet Patten's shop.

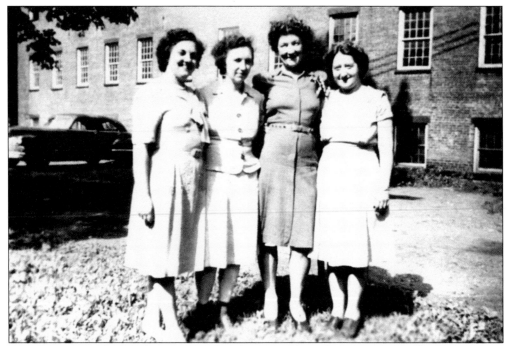

Seen here are employees of Troy Town Shirt factory in the 1950s. Harmony Mill No. 1 is seen in the background. Troy Town Shirt was in Cohoes at 100 North Mohawk Street (in the Harmony Mill complex) from 1950 to 1992. The last woman on the left is Rose Desmarais Borden. The mill workers (a predominantly female workforce) all did piecework, harkening back to earlier days in the mills.

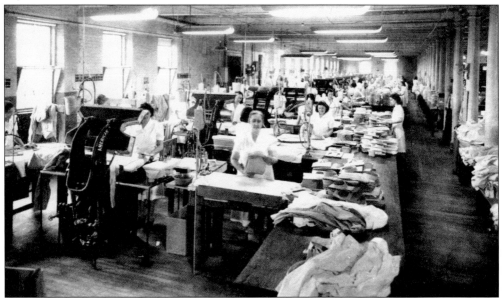

Troy District Shirt Company was incorporated at 305 Ontario Street around 1948. At the time, Ralph Shapiro was president and treasurer, Charles Marcus was vice president and Jacob Levine was secretary. This company manufactured shirts for Manhattan and J. C. Penney until the 1970s.

Six

1960

My dear Addie,

Another year is upon us! My best for the new year. We have been writing to one another for the past 70 years. My, we have shared so many joys and so many sorrows. The eyes are going and the pen is not as steady. If you don't mind, I shall ring you instead of writing in the future. Keeping my correspondence up with our family and friends in Cohoes is tough enough. You know me; I will not call long distance when I can use a 4¢ stamp. President Eisenhower should do something about that, prices these days are ridiculous.

Oh, Addie, I wish you would have made movies when sound came in. I would love to see you dance again. Does that short you made in 1897 even exist anymore? What about the fairy-tale based movies you made with J. J. in 1916? I guess times change, but my admiration for you does not. Some still remember you in Cohoes. I had a letter from a member of the Sister-Parent Association of Keveny Academy recently. They have two upcoming sales to benefit the Sisters of St. Joseph and they requested a donation from you from your days in vaudeville.

Oh, how I remember parading down Remsen Street with you and the family. Cousin Daniele just sent a letter describing Remsen Street today. Hundreds of electric lights were put up from Columbia Street to the north end to create "Santa Claus Lane." All the merchants on Remsen Street were opened every night in the month of December until 8:30. She named a few, let me recall. There was Irwin Jewelers, Cohoes Music Center, Carroll's Shoe House, Juliette's, Mr. Jules, and Marra's Pharmacy on Remsen Street and Cramer's on Mohawk Street. She did not even get to Miron's to check on the new carpet she ordered. Afterward, she had something to eat at Golden Krust. She said she bought her family an RCA record player at Smith Electric Company for $39.95 and paid the same at Timpane's for a Bell & Howell camera for her brother Paul. What a coincidence!

I recently received a postcard from High Tor. The scenery looks spectacular. Some of our Cohoes relations seem always on the road, much as you were in your performing days.

Some sad news. Monsigor Franklin passed away in December. Do you remember him? He was the pastor at St. Agnes church for many decades. Cohoes is not what we remembered. They are even dismantling some of the old stones from the canals and locks that we walked along when we were children. The huge limestone blocks from Lock 10 by Spring and Lincoln Streets are being moved all the way over to Dyke Avenue for a new causeway. A new concrete highway will be replacing the old wooden bridge that is currently in that area.

The city historian, Hugh P. Graham, just traced two other famous guests to the Van Schaick Mansion. One was that famous midnight rider Paul Revere. Kids today are probably thinking he started that new band Paul Revere and the Raiders. They probably would not even recognize the second famous visitor's name: Capt. Daniel Shays, of Shays' Rebellion fame. If any of the famous visitors now haunt the place, I do not know how they will sleep with all the trains going by. I remember how they frightened me as a child. (I will also never forget how Miss Jones laughed at my first letter when I referred to the Cohoes mastodont as a famous person from Cohoes. Ah, the days of our youth.)

I wonder if the children today can name all 50 states now that Alaska and Hawaii joined the other 48 this past year?

I also remember Father and all his discussions about the price of things. He probably would have given up coffee if it cost 69¢ like it does today. Mother would never have been allowed to bake a cake if he had to pay 39¢ for five pounds of sugar like it cost at the A&P this week. I read on the back of one of the clippings that was sent to me that the mayor of Cohoes is now making $4,000 a year. Father would have been irate.

Have you been watching *The Lawrence Welk Show?* Isn't it "wunnerful?" The bubble machine pumps away while those stars of the Welk family entertain (should I send your name in to be a guest?). I'm hooked on *The Untouchables.* I hope it continues for many more years so I can follow the real-life exploits of treasury agent Eliot Ness. Robert Stack is so handsome.

<div align="right">

I guess this is the final time I will close as . . .

Your loving sister, Helen

</div>

Myer Cramer, an immigrant from Lithuania, opened a tailor shop at 72 Mohawk Street in 1919. His stock consisted of a few pairs of socks, pants, and shirts. One day a group of farmers stopped at his store, looking to purchase shoes. Cramer told the farmers to come back in an hour and he would "have some bargains" for them. Within a few minutes, Cramer persuaded a Troy distributor to deliver a few dozen pairs of shoes to his shop. The farmers returned and bought shoes, and Cramer was in business. In 1972, Cramer's son Oscar took over the business and moved it into the former Cohoes Armory, from where he retired in 1992.

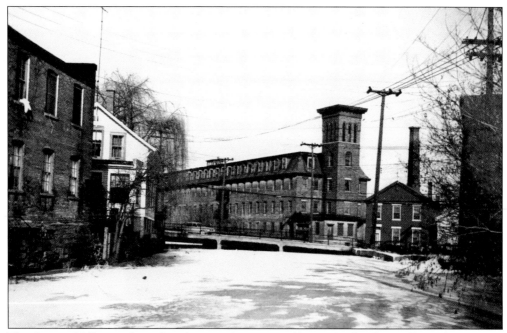

The Strong Mill was also referred to as Harmony Mill No. 5. The first mill on the site was built in 1846 but was destroyed by fire eight years later; it was rebuilt within the year. The Harmony Mills Company purchased the mill in 1865, enlarging it and remodeling the roof in the Italianate style with a mansard roof and imposing tower. The mill was demolished during "urban renewal" in the 1970s.

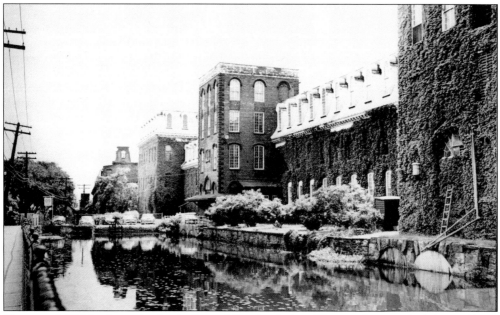

Harmony Mill No. 2 was in classic Second Empire design. The northern end of this mill was completed in 1857 and the southern end in 1866. Directly in front of the Mill is the power canal. The stone arches mark the exits of the tunnels that carried water released by the turbines at the back of the mill structure. This power canal was once a section of the original Erie Canal.

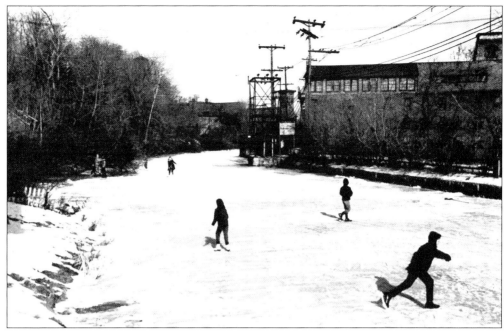

Cohoes became a center for recreational ice skating and competitive speed skating because of its canals and Carlson's Ice Rink, formerly known as the Cohoes Ice Rink. Speed skating was extremely popular in the region, especially between the world wars, and Cohoes was the site for numerous skating races. The Cohoes Ice Rink also hosted the first Rensselaer Polytechnic Institute hockey game, a contest against Williams College on January 25, 1902.

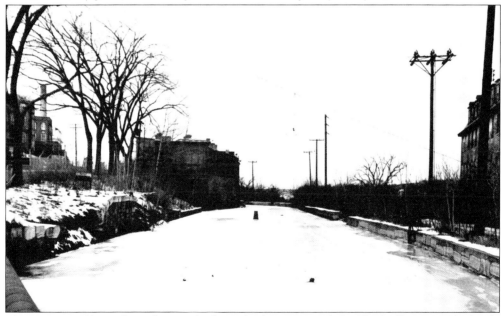

The Strong Mill, on the right, was built in the latter part of 1846 by William M. Chadwick. The mill housed 2,700 spindles, which supplied yarn for 80 looms. The mill consumed nearly 300 bales of cotton per year and employed 69 people. The Strong Mill, rebuilt after an 1854 fire, was purchased by the Harmony Company in 1865. The McCreary Machine Shop is on the left.

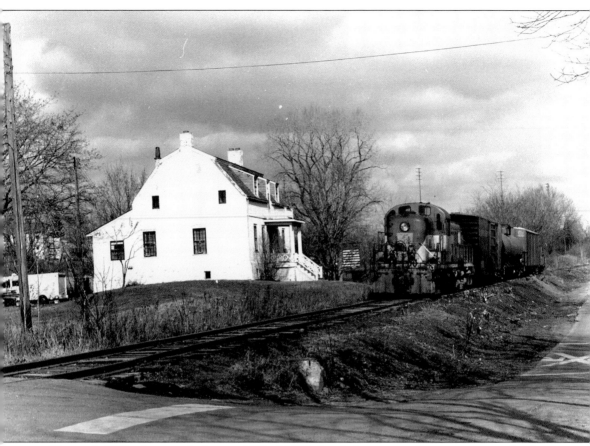

This early-1970s photograph shows a 1950s ALCO diesel electric switch engine moving freight in front of the Van Schaick Mansion, going south along a section of track, once part of the Rensselaer and Saratoga Railroad, that is no longer in place. These tracks saw passenger and freight service that brought the by-products of Cohoes's many manufacturing sites and its workers to and from the city. The railroad right-of-way in this section, including the bridge that connects Van Schaick Island to Green Island, is currently being converted to a recreational trail for bicycles and pedestrians.

David Fontaine and Roland Gallerie are seen in a radio store at 71 Johnston Avenue. The store had been a grocery and dry goods store owned by Napoleon Favreau. It opened in 1886 at 12 Willow Street, owned by Joseph and Henri Favreau; by 1895, Napoleon Favreau was the grocer. The store relocated to a larger building at 71 Johnston Avenue in 1915. This building is now used as a residence.

After this April 1959 ribbon cutting ceremony opened the rebuilt Reavy Bridge, traffic used this section of Ontario Street for the first time in months. Twenty minutes later, traffic was blocked again so that the 57 year old Champlain Canal bridge at Whitehall Street could be dismantled and replaced by roadway. Second from left in the center group is Public Works Commissioner Joe Archambeault and third is Mayor Roulier. The Reavy Bridge connects Van Schaick Island to Simmons Island.

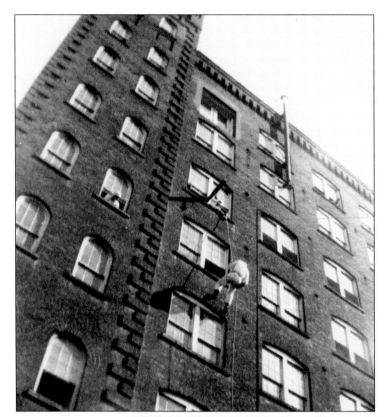

Civil defense exercises, a highlight of the Cold War, were conducted around the region during the 1950s and 1960s. These photographs, taken at the Cohoes Carrybag Mill in 1958, showed how these activities helped to familiarize fire and police departments with the latest response and rescue techniques to prepare for attack or natural disaster. In tall buildings that housed many workers, like the Cohoes Carrybag Mill, some of these drills were a safety requirement mandated by state and federal authorities.

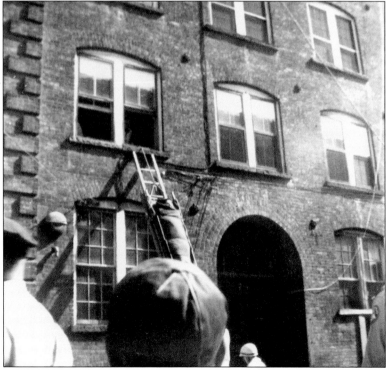

Officers and members of the Polish National Alliance (PNA) club appear in this photograph. From left to right are (first row) president Vincent Guzek, William Dobrucki, Mr. Zandri, Mr. Dobrucki, Mr. Guzy, and Edward Kloc; (second row) Joseph Ukleja, Joseph Kupiec, and Steven Kolacy. The PNA was a social and mutual aid organization that assisted Polish immigrants. In 1930, the group acquired a building at 81 Mohawk Street (formerly the home of the Odd Fellows Club) for their use.

This was the 1965 celebration of the 50th anniversary of the Polish Citizens Association. The association helped Polish immigrants, providing assistance in applying for citizenship and adjusting to a new country. The association purchased a building on Linden Street in 1917 for use as a clubhouse. In 1966, the Polish Citizens Association and the Sons of Poland joined with St. Michael's Fraternal Society to become St. Michael's Community Center Incorporated.

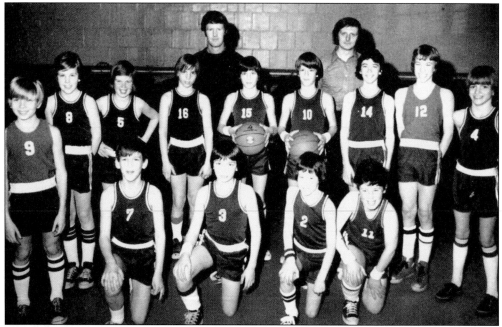

Cohoes consolidated several Catholic schools in 1971 because of rising expenses and the dwindling number of nuns available to teach. Students in kindergarten through fifth grade from St. Joseph's, St. Agnes, and St. Marie's attended St. Marie's School, and sixth through eighth grade students attended St. Agnes School. Here is the 1974 Cohoes Catholic Consolidated School's seventh and eighth grade basketball team. Coach John Craner and athletic director Jim Amyot stand in back.

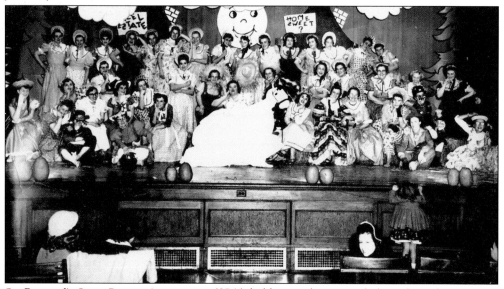

St. Bernard's Sister-Parent Association (SPA) held a yearly minstrel show for a few years in the 1950s. The shows featured unique costumes and stage decorations, and included songs and dances from 10 nations. The production was staged at Keveny Academy. During this 1956 program, a cast of 240 performers participated, including the senior choir and the vested choir of the church.

Numerous civic groups and businesses designed floats like this one for the parade celebrating the Cohoes centennial. Many Cohoesiers dressed in 19th-century attire and formed groups (often with amusing names) to participate in centennial events. Among these groups were the Bunker Hill Bootleggers and Bushwhackers, Ye Old Brewery Boys, Virginia's Vigilantes, the Blue Ribbon Beersmen, the Cohoes Hospital Astra Naughty Belles, the Erie Canalers, and Big Mike's Gang.

Lock 15 of the enlarged Erie Canal is seen here. This was the canal's second generation, constructed in response to the incredible success of the original canal. Locks 9 through 18 (of 72 locks across the entire canal) were located in Cohoes, the highest number in any community along the canal system. The large number of locks was necessary for lift around the Cohoes Falls. Remnants of nearly all of these locks can be visited today.

This interpretive sign was developed through a partnership between fifth grade students at Hewitt and Riverside Elementary Schools in Rockville Centre, New York, and the Spindle City Historic Society. The students adopted canal sites in Cohoes and raised funds for their preservation. From left to right at the September 17, 2005 dedication ceremony are Cohoes mayor John McDonald, Hewitt school principal Joanne Spencer, and Spindle City Historic Society president Paul Dunleavy.